CHIPPENHAM

THROUGH TIME

Mike Stone

AMBERLEY PUBLISHING

January 2013.

Dear Betty,

Perhaps this will persuade you
to come and see this town.

With love

Astrid

First published 2012

Amberley Publishing
The Hill, Stroud
Gloucestershire, GL5 4EP

www.amberley-books.com

Copyright © Mike Stone, 2012

The right of Mike Stone to be identified as the
Author of this work has been asserted in accordance
with the Copyrights, Designs and Patents Act 1988.

ISBN 978 1 4456 0913 3

British Library Cataloguing in Publication Data.
A catalogue record for this book is available from
the British Library.

Typeset in 9.5pt on 12pt Celeste.
Typesetting by Amberley Publishing.
Printed in the UK.

Contents

Acknowledgements

I am very grateful to the following people and organisations for their kind permission for the reproduction of photographs and illustrations and their assistance with the ongoing story of Chippenham: Peggy Burgess; Richard Iles and family; David Powell; Tony White; Avice R. Wilson; Mike and Annette Wilson; Bill and June Wood.

I would particularly like to thank Don Little for the loan of most of the illustrations in this book and his continued assistance in researching Chippenham's history. Also, the many past members of the Chippenham Civic Society, who have written so many useful articles on Chippenham's history in their quarterly publication, the *Buttercross Bulletin*.

The staff of the libraries and archives at the Wiltshire and Swindon History Centre and the Chippenham Museum & Heritage Centre.

Finally, I would like to thank my wife Marilyn for so much assistance in bringing this book to birth, along with Rosie Rogers and Sarah Parker of Amberley Publishing.

Introduction

The market town of Chippenham is a diverse, growing community with new industries, new housing estates and a growing population, many of whom commute. Like many market towns Chippenham has a long, diverse and interesting history. The horseshoe bend of the River Avon attracted early prehistoric hunters, who were followed by farmers in the Bronze Age, Iron Age and Roman period. It was the Saxon kings of Wessex who put Chippenham on the historical map; they built a royal palace near the church, and the town had a strong association with King Alfred the Great.

The main economic base of Chippenham within its hundred was agriculture. The town ran a bustling medieval market and received its Borough Charter in 1544. By the Tudor period the town was involved in the wool industry, which grew substantially in the eighteenth century. The wealth of many of the town's burgesses was used to both improve and build new Bath stone town houses in the High Street, Market Place and St Mary Street. In 1798 the town had a short flirtation with the Wilts & Berks Canal, with a branch that terminated at the wharf under the present bus station.

In 1841, the arrival of the Great Western Railway was said by many at the time to be 'much needed' and ' awakened the town's inhabitants'. Many of the Chippenham industries that were involved in milk, butter and cheese prospered with the arrival of the railway. In 1842, Rowland Brotherhood set up his own railway works north of the station, followed in 1894 by Evans O'Donnell, who built a new works further north, and later they joined up with Saxby & Farmer. In 1920, they merged with the Westinghouse Brake & Signal Company. The town's long association with railway engineering has somewhat declined and has been replaced from the 1970s with smaller, out-of-town industrial trading estates.

The town's heritage through time is well displayed in the Chippenham Museum & Heritage Centre, along with a number of important buildings

and monuments such as the re-erection of the Buttercross in 1995, renovation of the town hall and Need Hall in 1996 and the renovation of Yelde Hall in 2002. Like many market towns, redevelopments in the 1960s and '70s have removed many good architectural buildings. They have often been replaced with modern architectural styles which are not always very popular with the communities.

The lost heritage of Chippenham can be viewed through time by looking at old etchings, paintings, illustrations and photographs. This new book on Chippenham looks at the changing face of civic and public buildings, some of which we have lost and some of which have changed use. The agricultural economy of the town was centred on its market, which has been moved two times and is sadly no longer in existence, although the large Market Place stands testament to its former use. Buildings in the High Street and New Road are still a mix of both domestic and retail use, but quite a few of the eighteenth-century Bath stone buildings have been demolished, along with the stone bridge and the imposing mill. The building of Station Hill to serve the station opened up a whole new area for public buildings and new educational buildings.

In trade and commerce there have been enormous changes in both the type and ranges of shops offering goods to the public. Again, many of these shops have been revamped and many have been returned to domestic usage. In the wine-and-spirits trade, public houses have continued to close, with many reverting to domestic use. On the outskirts of the town only some of the large Victorian and Edwardian houses have survived, while in the suburbs of Chippenham there is still a good stock of both Victorian and Edwardian houses that, apart from some cosmetic changes, look strikingly similar to their pictures from the past. The town's religious buildings have shrunk somewhat in number, but they still have a major presence both in the town centre and the outskirts. The arrival of the Great Western Railway changed the face of Chippenham forever, creating new industries and new jobs, and is still a good servant to an expanding town that has fostered and maintained an interest in its past heritage.

Chapter 1
Civic and Public Buildings

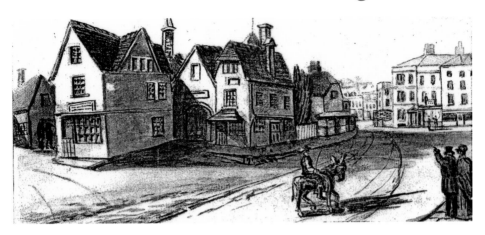

Yelde Hall

The construction of this civic building occurred sometime after 1458 and it was built in the middle of the open Market Place. The building was originally used as a market hall, with internal divisions for different traders. It was also used for temporary law courts by High Court judges on their circuits. The upstairs chamber above the hall was used by the bailiff and burgesses for local government meetings. Beneath their chamber was the blind house or lock-up, which was built of stone to deter any breakouts. Over time, buildings began to be built against outside walls of the hall, including Mr Long's umbrella hospital, a tobacconist and an auctioneer's house. These were all removed in the 1950s as part of an ongoing programme of restoration, and in the 1960s the hall became the home of Chippenham's first museum. After a spell as the town's tourist information centre, the building has again come back into use as an annex to the Chippenham Museum & Heritage Centre for exhibitions.

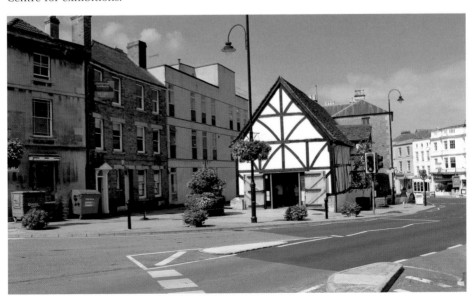

New Town Hall

The MP for Chippenham, Mr Joseph Neeld, paid for the erection of a new town hall in the High Street in 1833 at the cost of about £12,000. He purchased the land and employed the architect James Thomson to come up with an imposing classical building that would suit the growing community of Chippenham. In 1850, the town hall was extended at the rear to include a large area for a cheese market, corn exchange and other areas for trading. The *Illustrated London News* produced a picture showing the cheese market in full flow on 12 September 1850.

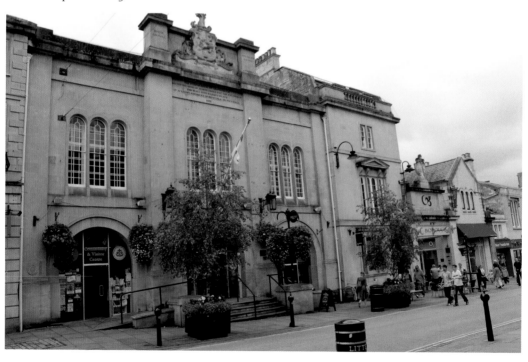

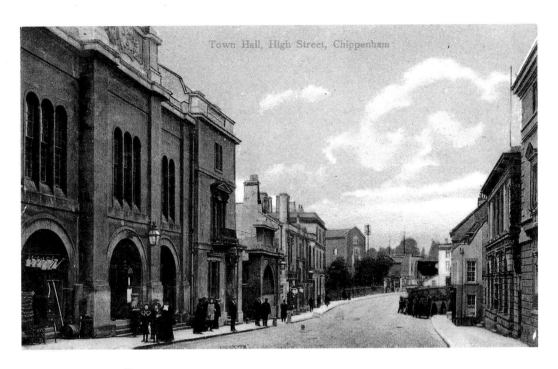

New Town Hall

Part of the overall design was a large, free stone arch fronting onto the High Street, with the old Borough coat of arms in carved stone and the motto 'Unity and Loyalty'. This led through into the cheese market. From 1910 the cattle market was relocated here, and this formed the main public access on market days. In 1996, Chippenham Town Council restored and renovated the town hall and relocated their offices within. The building contains the town hall, Neeld Hall and the town's tourist information centre.

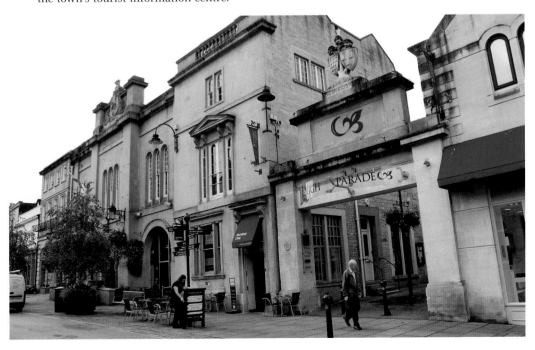

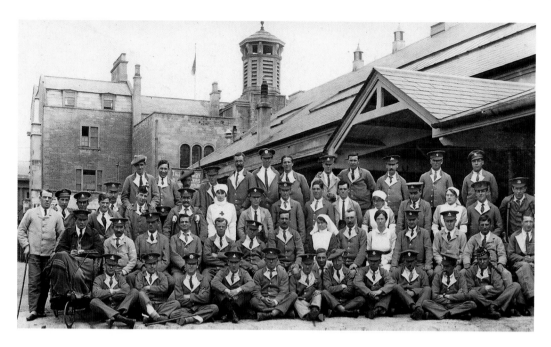

Town Hall Precinct

During the First World War, the town hall and the cheese market were turned into an auxiliary military hospital. Over 1,800 soldiers from all over the British Empire who were not too badly wounded were sent here to recuperate with the highly motivated Voluntary Aid Detachment nursing staff. On 19 July 1919, a very large Peace Day celebration and meal was held in the Neeld Hall to commemorate the end of the war. In the 1980s, the area known as the precinct behind the town hall was developed as a shopping area with one public house. Most of the area was once the site of the cattle market when it relocated here in 1910.

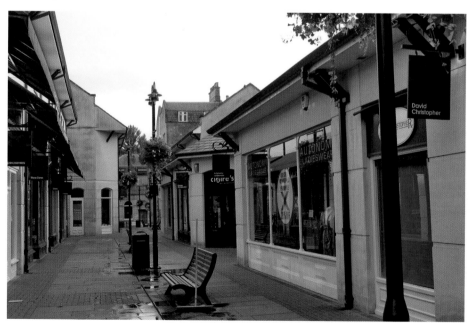

Jubilee Buildings

Early in the year of Queen Victoria's Golden Jubilee of 1887, the town had decided to obtain funds for a celebration of the Queen's Jubilee but also to erect a handsome building as a literary and scientific institute, which would serve as a lasting memorial. Sir John Neeld presented the site in the marketplace next to Spink's Printing Works. Public subscription raised £1,000 towards the building, which was duly constructed and became an important asset to the Chippenham community, with reading and recreational rooms and areas kept aside for the technical education in art, chemistry, French, shorthand, bookkeeping and typewriting. The building today is the home of the Chippenham Borough Lands charity, and the old reading and recreation rooms are still hired out to the local community.

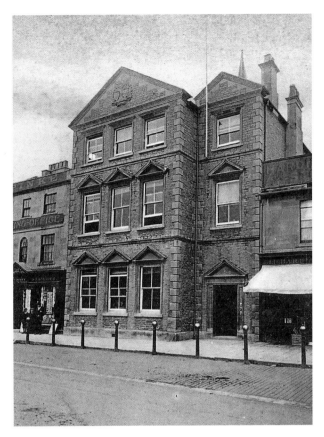

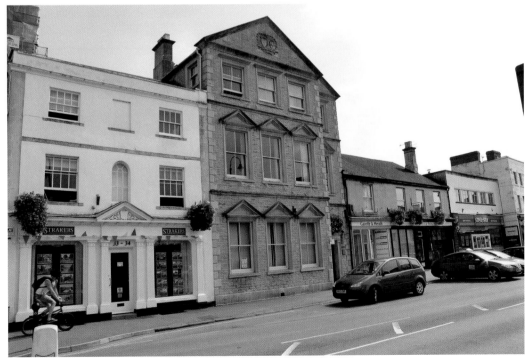

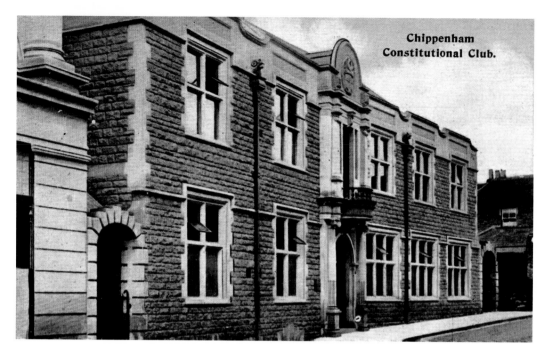

Chippenham Constitutional Club.

Constitutional Club

The Chippenham Conservative Association had reading rooms in The Causeway from 1889 before they moved to 3 High Street in 1890, where the idea for a constitutional club was first discussed. After a short time at The Little Ivy, which was a licensed premises, the club was called the Chippenham Conservative Club. In 1908, a contract was signed for the erection of new premises in Foghamshire; the work cost £2,427 and required the purchase of land covering five cottages. The style of the building is described as Revival English Renaissance, and it was officially opened on 5 May 1909.

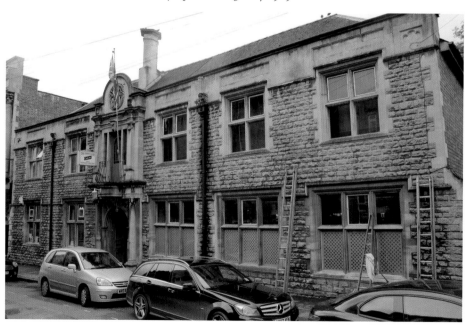

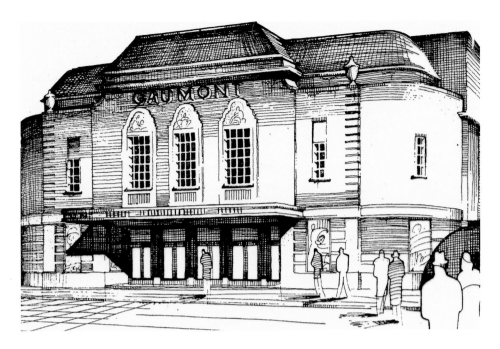

Gaumont Cinema

At 2 p.m. on 14 November 1936, the Gaumont-British Picture Corporation opened their new cinema in Timber Street. The mayor of Chippenham, Mr G. L. Culverwell, opened the cinema and in attendance was the manager, Mr Harry Falls, who had been the manager at the Palace Cinema in Station Hill. The architect was Mr William Edward Trent, who worked with his son and his cousin Newberry Trent, who probably sculpted the three panels on the cinema front. The exterior was in a Georgian style, with three carved stone panels representing the 'Spirit of the Cinema', with the two attendants 'Light' and 'Sound' on either side. In 1964 the Gaumont chain was bought out by J. Arthur Rank and the building was renamed the Odeon. In 1967 the Odeon was sold and became part of the Classic circuit, until it closed in 1974 and became part of a chain of discos and nightclubs. In 2004 the building was demolished and has been replaced by a retirement home called Castle Lodge. Thankfully, the three carved stone panels have been saved and placed on the front of the new building.

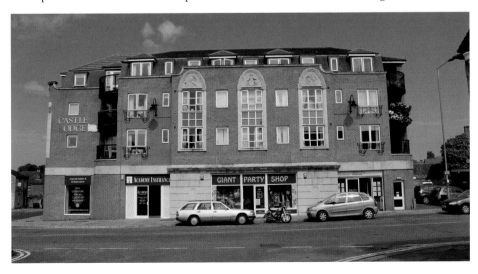

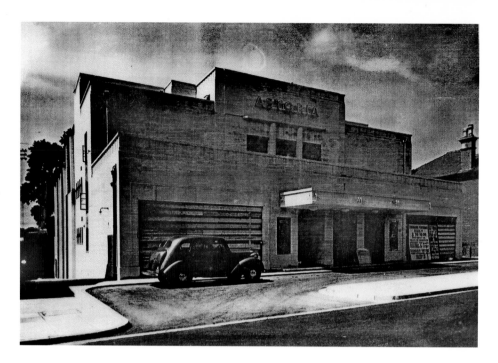

Astoria Cinema

The new Astoria Cinema showed its opening film on 29 May 1939, which was *The Citadel*, starring Robert Donat. The cinema was part of a chain owed by Emmanuel Harris, who had commissioned the architect William Henry Watkins to design the cinema. The original plan was for a larger building, including a restaurant, but the scheme was much reduced. In 1967, the cinema was divided up by a bingo hall on the lower ground and the cinema in the upper stalls area. In 1973 the cinema was again divided, due to growing demand for the multiple programming of films. The cinema is now owned by Reel Cinemas, who have plans to redevelop the whole site.

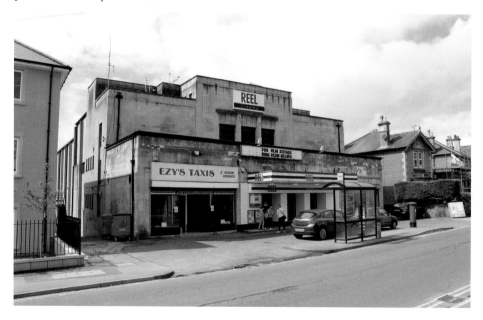

Old Salvation Army Building

In 1903, the Salvation Army building was constructed at the end of Bath Road next to the town bridge. With its castle-like crenellations, it was aptly named the Citadel. The Salvation Army left the premises and moved to the larger old Co-op hall in Foghamshire, where they still are to this day. The old Citadel was first acquired by Pictons and has had various tenants, ranging from the town's tourist information centre to a bric-a-brac centre, and currently it is used on the ground floor by Mail Box.

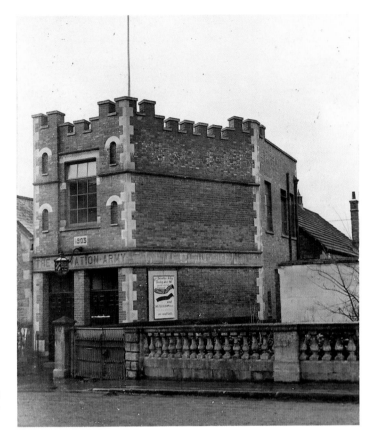

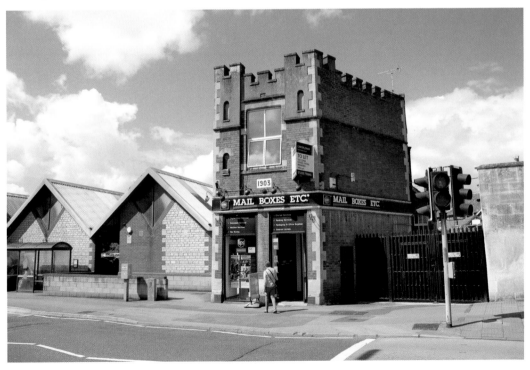

Chapter 2
Market Place

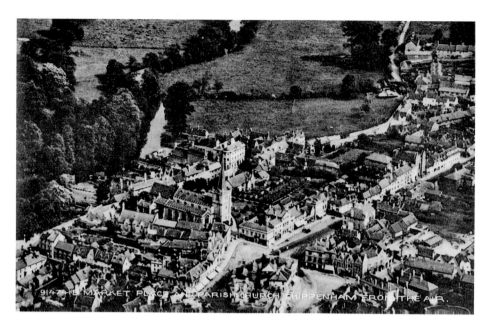

Market Place from the Air

The aerial shot shows Market Place, with St Andrew's church to the left and the butchers' shambles area to the middle-bottom, in the early 1900s. Part of the same view from the top of the church spire shows Yelde Hall on the edge of Market Place, with the shops and buildings running from the top end down into the High Street.

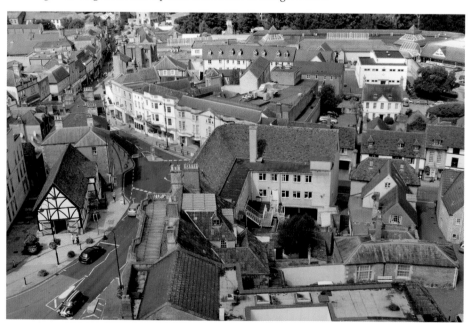

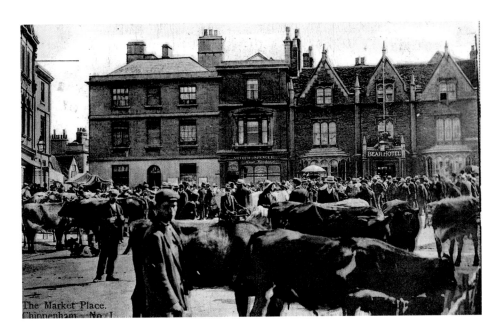

The Market Place.
Chippenham. No.1

Cattle Market

The town has probably had a cattle market from the thirteenth century, when the rights to the market were divided between the Hussey family, lords of the manor of Rowden, and the Gascelyn family, who held the two manors of Sheldon. Later the Hungerford family acquired the market rights; they then reverted to the Crown and were then granted to Lord Darcy, who sold them to Mr Sherington of Lacock abbey in 1553. In 1784, the market was held on Saturdays and the livestock were allocated to different areas – pigs in Timber Street, horses in front of the Bear Hotel, sheep from the Angel Hotel to River Street, cows outside Yelde Hall and bulls tethered to iron posts at the front of the Jubilee building.

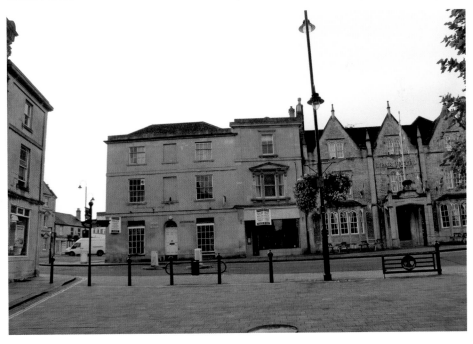

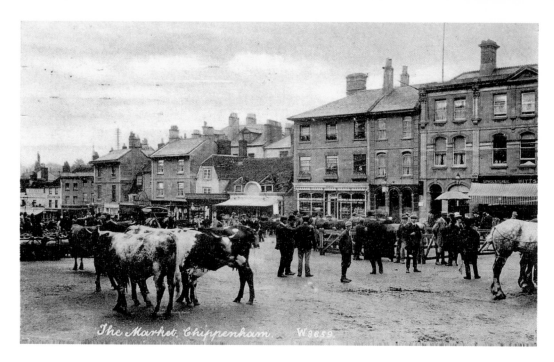

Cattle Market

The market prospered in Victorian times but by the beginning of the Edwardian period the Borough Council had to move the market as the Board of Agriculture had prohibited the holding of cattle markets in streets. The market was then moved to the rear of the new town hall in 1910. The marketplace, with the re-erection of the Butter Cross in 1995, has been turned back into a traffic-free area, where markets are again held on Fridays and Saturdays.

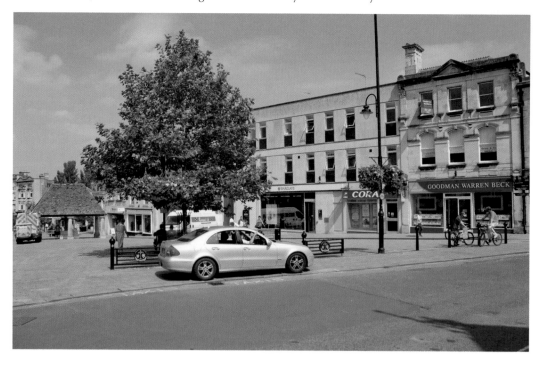

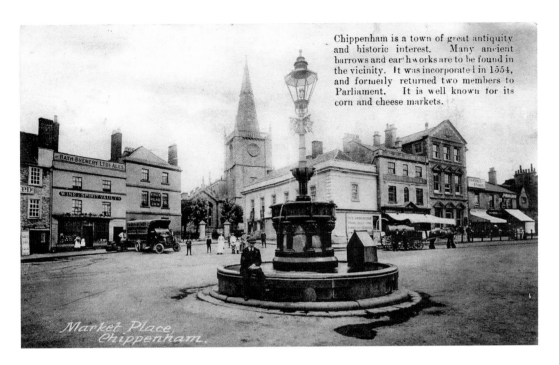

Chippenham is a town of great antiquity and historic interest. Many ancient barrows and earthworks are to be found in the vicinity. It was incorporated in 1554, and formerly returned two members to Parliament. It is well known for its corn and cheese markets.

Market Place, Chippenham.

Market Memorial

The town's ornamental fountain was erected in 1879 over the old well and pump that brought up water to feed the livestock during market days. The town's First World War memorial was paid for by public subscription and was attached to the rear of the existing ornamental fountain. The memorial was designed by Mr G. Parker-Pearson of Grittleton, and it was constructed of Hornton stone from Oxfordshire. The war memorial and fountain has been renovated on three separate occasions and still forms the focus for the town's remembrance services.

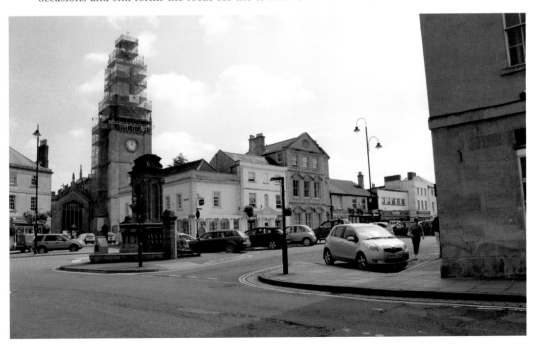

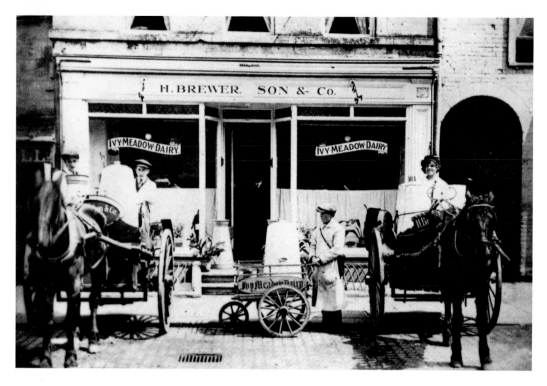

Ivy Meadow Dairy

There were many Chippenham milk companies supplying milk from churns in Chippenham up to 1919, but only the firm of H. Brewer & Son from the Ivy Meadow Dairy continued to supply milk from horse-drawn carts and a push wagon at about 4*d* a quart. All the other milk companies in Chippenham had now moved to supplying milk in glass bottles with cardboard tops.

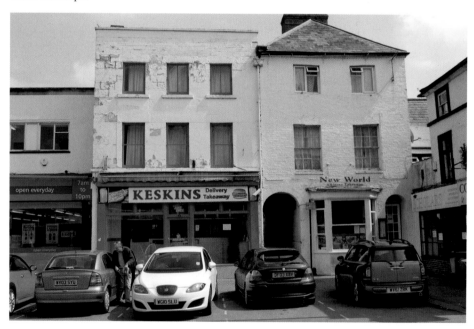

Doc Couch, Chemist

The chemist shop run by William Couch was set up in 1900, and the owner was the first in the town to start producing and selling specific medicines for his patients' ills. For over fifty years he looked after the needs of his customers and was affectionately known as 'Doctor Tonic' or simply 'Doc'. In 1951 his shop, at 42 Market Place, was compulsorily purchased and later demolished for the erection of the new post office. Doc Couch moved across the road to No. 58 in The Shambles, retiring in 1960 at the age of eighty-six.

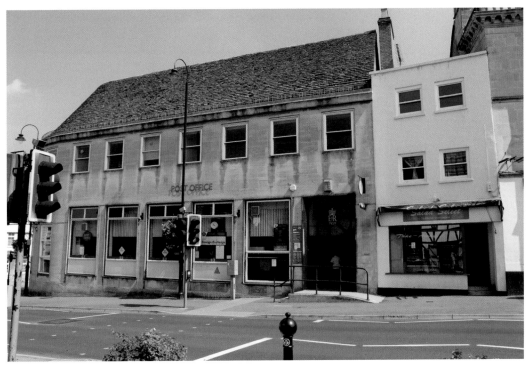

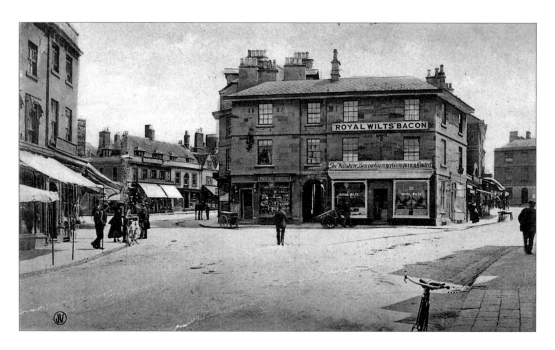

Royal Wilts Bacon

The corner of The Shambles, where the Royal Wilts Bacon Company shop stood, was formerly the site of the Kettle public house, which burnt to the ground in 1839. The shop was the main retail outlet for the company in the town, where products were brought from their factory, which grew up inside the old Brotherhood railway works, now Hathaway retail park. The Royal Wilts Bacon Company was once one of the largest curing factories in the South West and eventually became linked with the Harris Bacon Company at Calne.

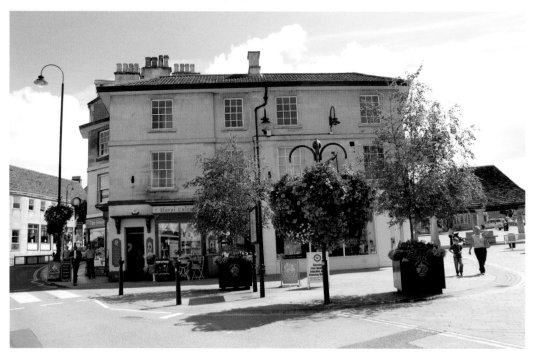

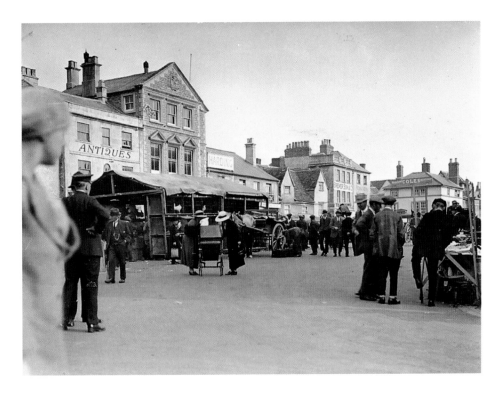

Market Auctions

The large, open area of the market was used on market days for the setting up of temporary pens for animals and market stalls. On other occasions the market was used for public auctions, which attracted a good deal of interest. The picture shows a long, temporary stall that was selling chickens. This area of the market today is no longer used for market trading and forms part of the road and an area for parking.

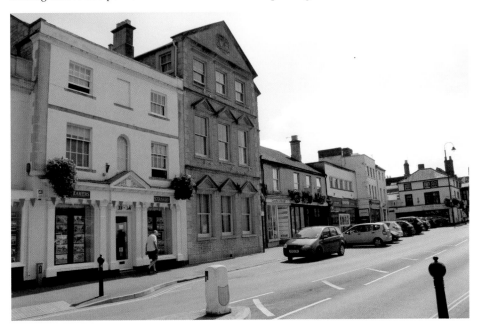

Chapter 3
High Street to New Road

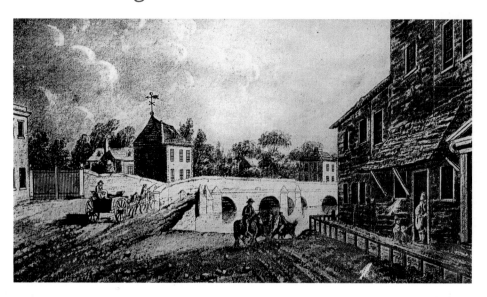

Town Bridge

Chippenham's first stone bridge was constructed in the sixteenth century, for in Queen Mary's charter of 1554 money was granted for a 'certain great bridge over the River Avon'. One of the earliest illustrations of the bridge dates to 1792 and was published in a book by Robertson on his 'itinerary of the London to Bath road'. The rutted roads lead up onto the bridge, with a house used as a toll-house to collect money for the upkeep and repair of the bridge. The ramshackle buildings to the right have been replaced by the old Co-op building, which is now occupied by Wilkinson's.

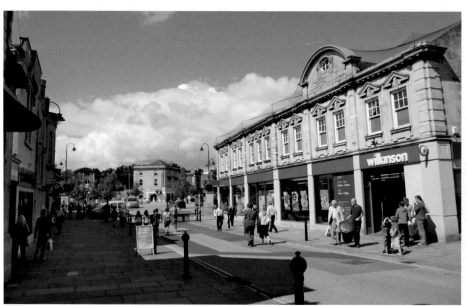

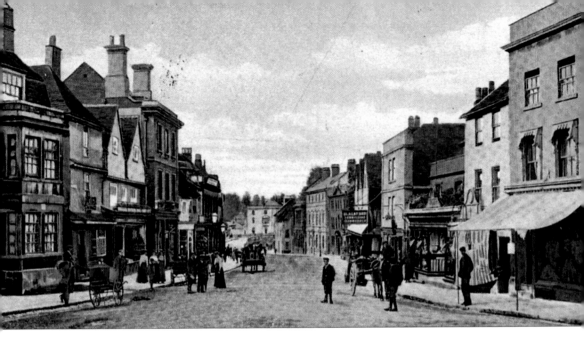

High Street
In the Victorian and Edwardian periods, the High Street still had a fine panorama of well-built, Georgian Bath stone clothiers' houses, with a few Tudor and Stuart box-frame timber buildings. The view today shows clearly how many of these fine buildings have been altered behind their front façades or demolished, sadly to their architectural detriment.

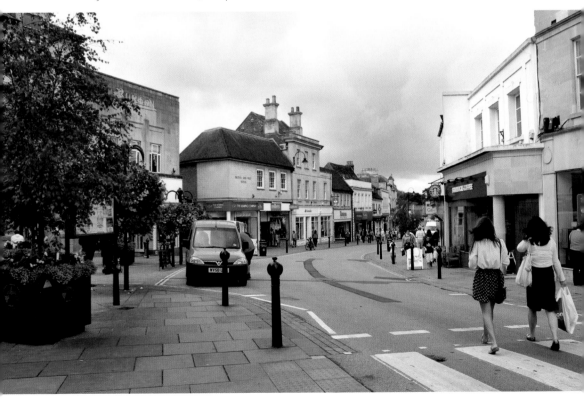

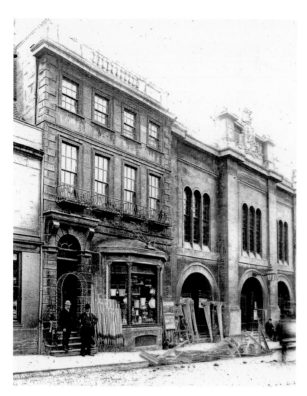

Gardner

The fine Georgian building next to the new town hall was turned into one of the town's ironmongers by Mr W. Gardner. The building was formerly a private dwelling which, like many other houses in the High Street, has been turned into retail outlets. Mr Garner is standing on the steps of the shop with displays of hand tools, which are also leaning against the railings of the town hall on a non-market day.

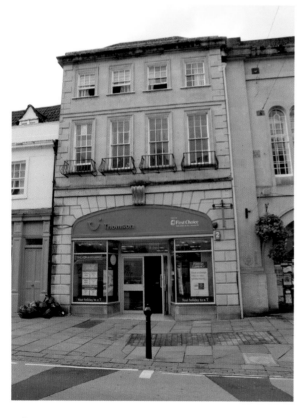

Blackford Ironmongers

Blackford ironmongers moved into their new shop, with rooms above, in 1908. Prior to this the area of the new building consisted of a row of medieval timber buildings. The first ironmonger to inhabit them was Lines & Leonard in 1895. In 1896, Albert Blackford set up the business of ironmongery. In the 1960s the international stores moved in. Recently, both the shops and the rooms above have been renovated and restored.

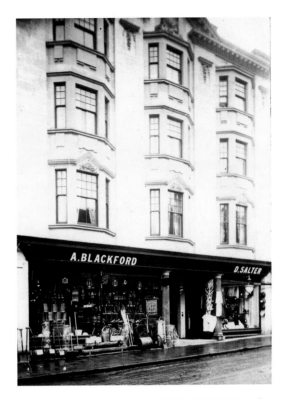

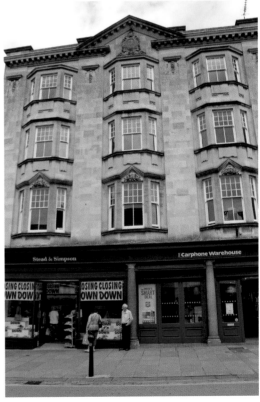

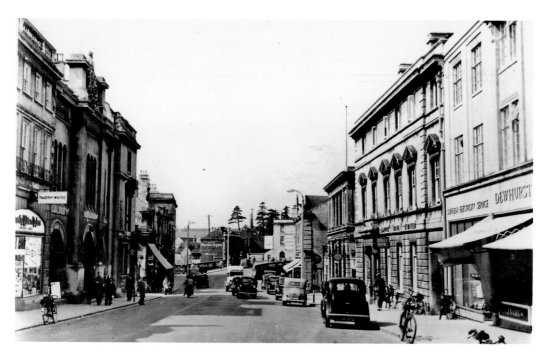

Lower High Street

Chippenham's High Street was once the main traffic road through the town, until the Avenue la Fleche bypass was constructed. The buildings shown here in about 1950 have changed very little, except that most of them have now been cleansed of their pollution, caused by the many coal fires in the town.

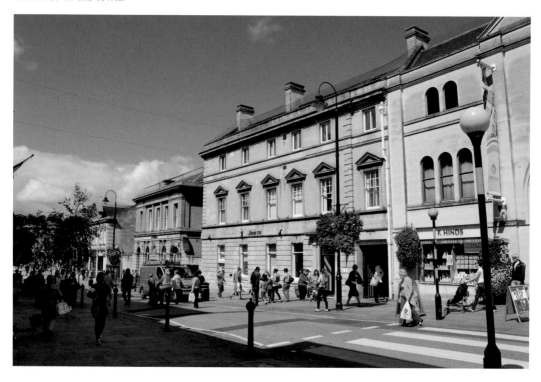

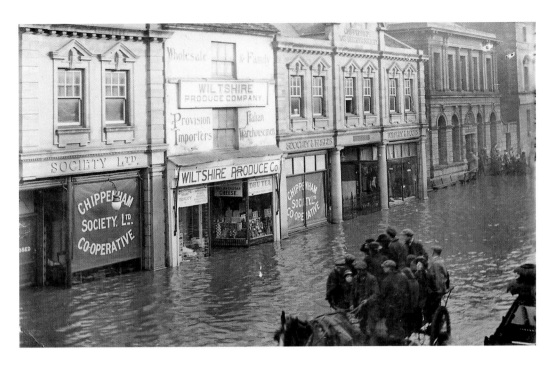

Chippenham Floods

On 19 January 1918, the river flooded the High Street as far up as Lloyds Bank. The picture shows that most of the Co-op was underwater and the people were being ferried through the floods in horse-drawn carts. The first major flooding was in 1866 and the last serious flood was on 11 July 1968. The construction of a wharf and organised water control has lessened the risk of major flooding today.

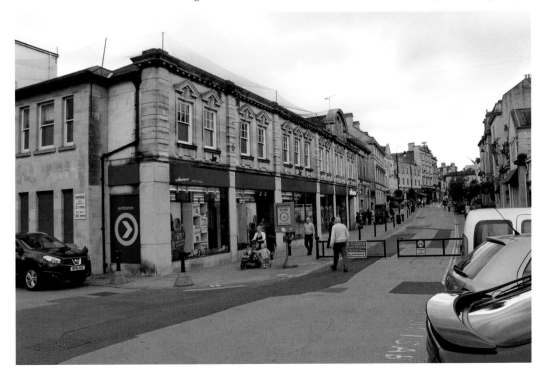

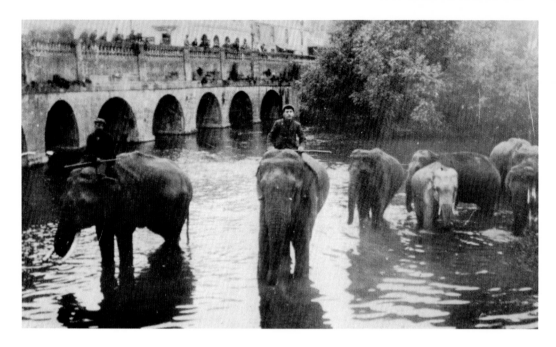

Town Bridge

The side of the River Avon near the bridge had a natural slope which easily allowed Bostock and Wombwell's travelling circus elephants to have a 'wash and scrub up' with their trainers in 1906. The elephant trainer was probably Arthur Feely, who was born in Bath in 1870 and joined the circus in 1897, touring Europe and Britain. After a long life working in circuses and zoos, he retired to Kent and died in 1955. This access ramp no longer exists due to the new bridge, but a new railed area allows the public to feed a wide range of bird life.

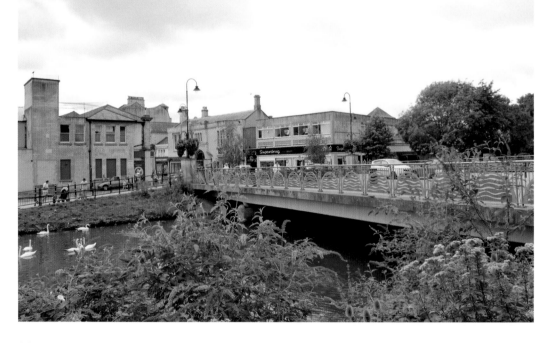

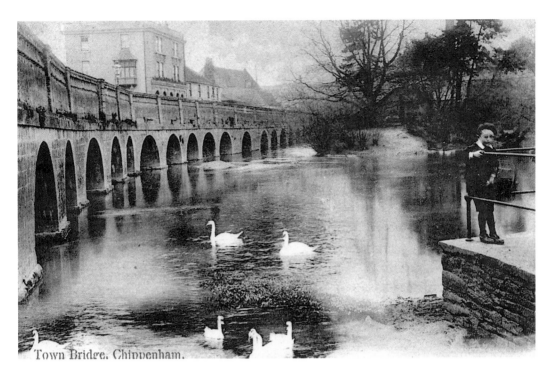

Town Bridge. Chippenham.

Town Bridge

Across from the river access ramp, most of the twenty-five stone arches of the bridge can be seen. In 1796, the bridge was widened and new ornamental balustrades of Bath stone were added. The old stone bridge was removed in stages and replaced by the existing bridge, which was officially opened on 2 May 1966. Probable offspring of the swans are still in existence!

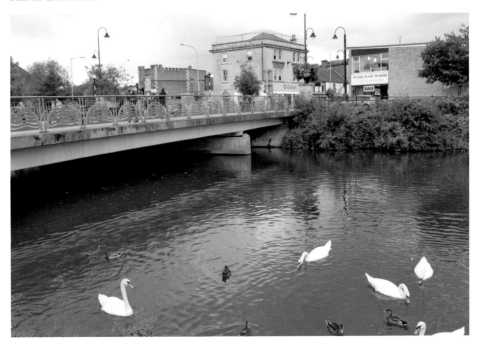

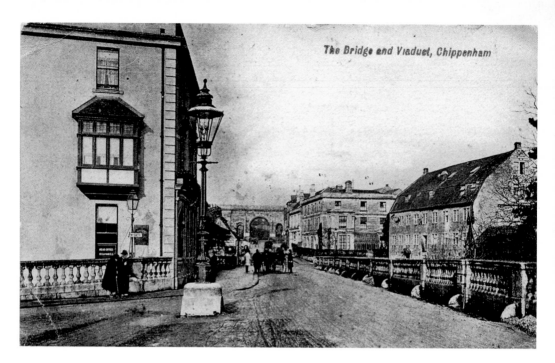

The Bridge and Viaduct, Chippenham

New Road

The striking building on the left of the picture, with its fine oriel window, has had a wide range of retail use. One of the town's well-known retail outlets was the Redwood Brothers, who sold men's and boys' clothing. After the building had been modernised and the oriel window was removed, it was occupied by Halfords and is now the Oxfam charity shop.

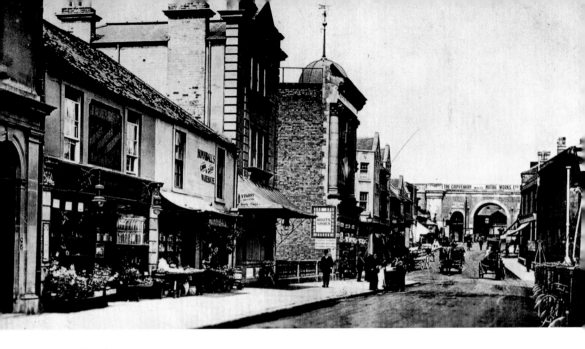

New Road

The area to the left of the picture was part of a speculative development in about 1905, which was never completed. Some of the small shops were pulled down and larger buildings were built in an Edwardian Neoclassical Revival style.

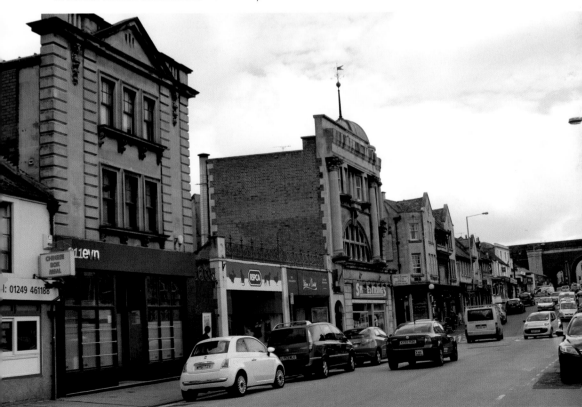

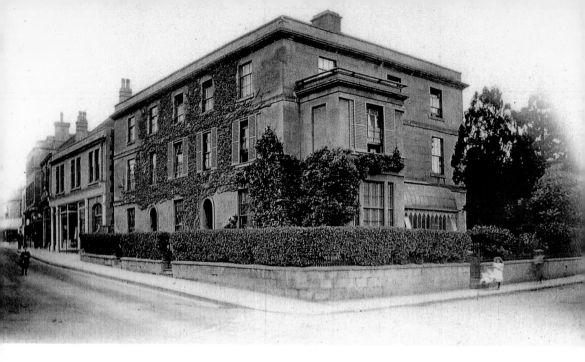

Collen's Town House

In December 1816, the nearby town mill caught fire and was rebuilt in 1817. For almost 150 years, the business of milling had been in the hands of three generations of the Collen family. Their fine Georgian town house stands next to the mill and ceased to be a domestic dwelling when in the 1960s it became the Westminster Bank. The building is currently occupied by Goughs, the solicitors.

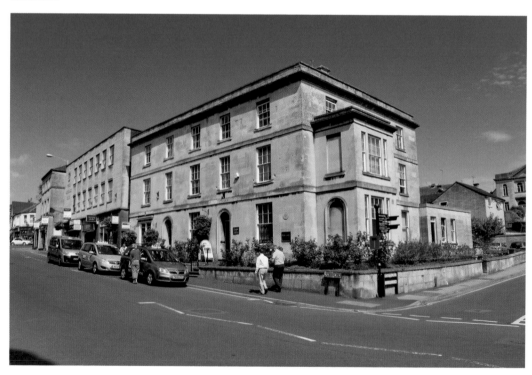

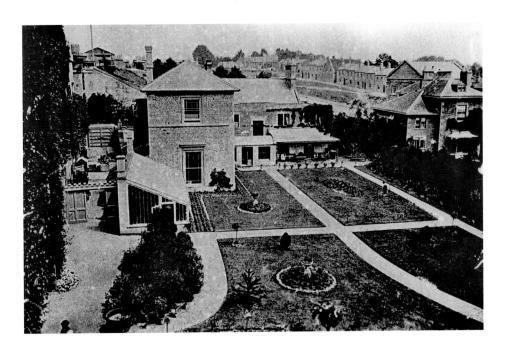

Orwell House

This house, built by Mr Provis, was rented by Rowland Brotherhood and his family, who eventually purchased it and added a fine new wing to the rear, with a dining room and master bedroom above. Rowland Brotherhood ran his own successful railway business in Chippenham and needed the larger house as his family consisted of eleven sons and three daughters. The conservatory and fine manicured lawns, complete with croquet lawn, were finally swept away when the house was turned into various retail shops. With the arrival of the relief road to the rear, which went through one of the railway viaduct arches, the garden finally disappeared. The area of the garden towards the house is now covered by the Brunel Rooms public house and a large charity shop.

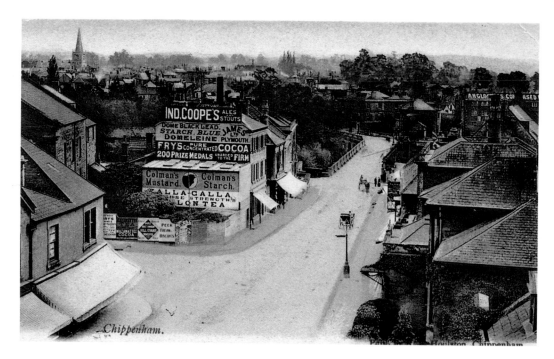

New Road from the Viaduct

One of the favourite vantage points for many Chippenham photographers was to stand on Brunel's bridge looking up and down New Road. Mr R. Houlston took this picture in about 1880, looking down New Road towards the Chippenham bridge. The many advertising boards at the foot of Station Hill were a feature of this corner for some considerable time. The small garden area in front of the hoardings has a single-storey building on it, which has had many uses, ranging from haberdashery to the current Indian restaurant.

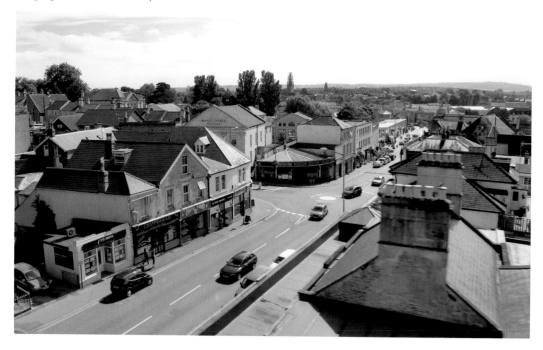

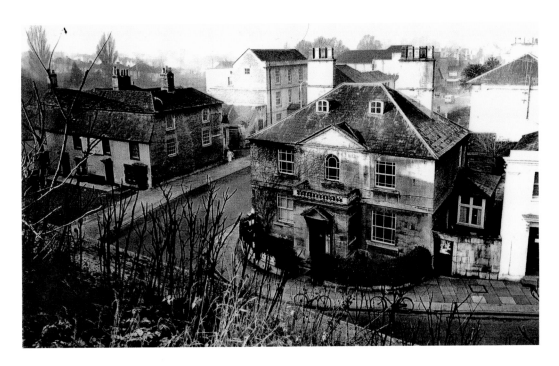

Malmesbury Road from the Viaduct

The photographer's view from the embankment leading to the bridge is a little obscured by growth on the bank, but to the left can be seen the Great Western Railway hotel and further buildings down Marshfield Road, all of which were demolished in 1967. The fine Victorian town house on the right was also demolished as part of the new road scheme in this area. One of the original monkey puzzle trees was kept and next to it was erected a large government office block.

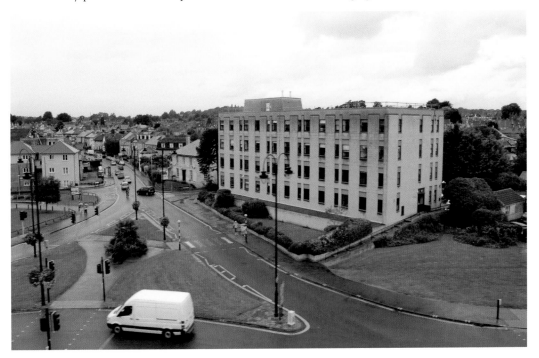

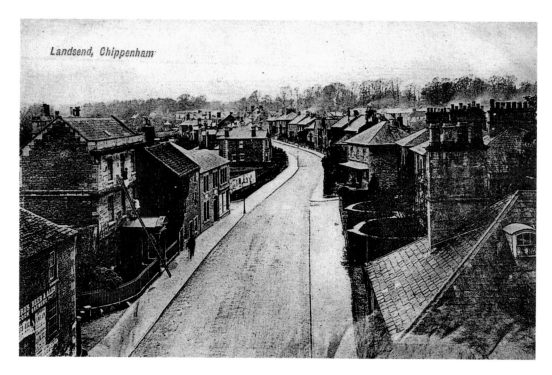

Landsend, Chippenham

Landsend from the Viaduct

For this view the photographer looked directly down Marshfield Road which, prior to 1906, was called Landsend. The four buildings on the left and the first four buildings on the right were demolished in 1967 as part of the scheme to build new roads and an underpass. The major new building here was Bewley House, originally built as offices for North Wiltshire District Council.

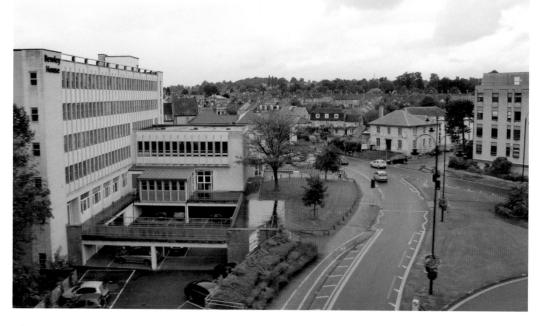

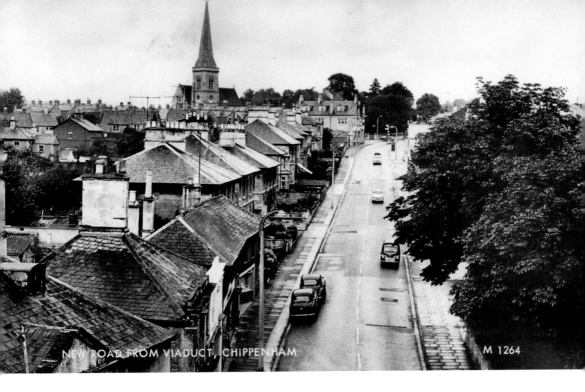

New Road from the Viaduct

The photographer, in about 1960, was looking directly up New Road, with St Paul's church in the skyline. Little has changed apart from the removal of some of the large trees on the right and the demolition of the house on the bottom left to improve the road access out of New Road, which is now one-way.

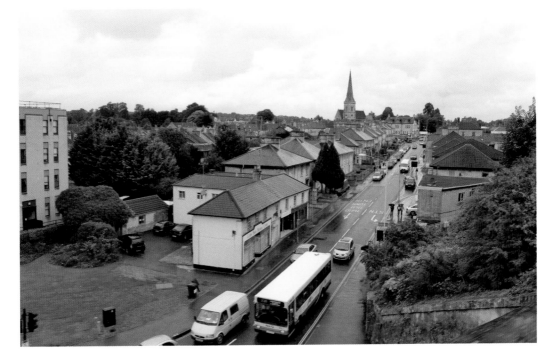

Chapter 4
Station Hill

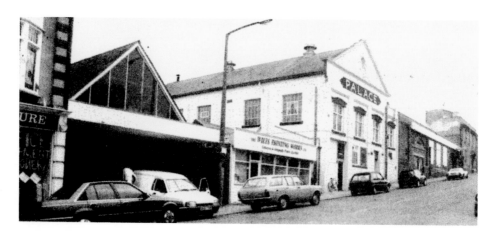

Palace Cinema

By 1910, regular performances were being shown at the new 'electric theatre' public hall. In 1915, Mr Albany Ward obtained a cinematographic licence and had the public hall enlarged and converted into the Palace Cinema. Film shows were very cheap and attracted huge numbers of adults and local children. In the 1930s the cinema was owned by the Gaumont-British Picture Corporation, who decided to build a new large cinema in Timber Street, which opened in 1936. The Palace then closed and for a short time was used by Westinghouse as a store, then becoming a snooker club and a nightclub, which is currently closed. The Wilts Printing Works and garage below the Palace Cinema have now been demolished and replaced with modern flats.

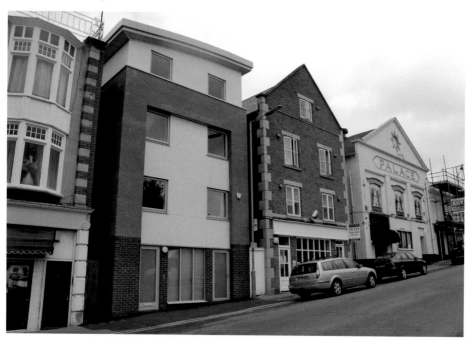

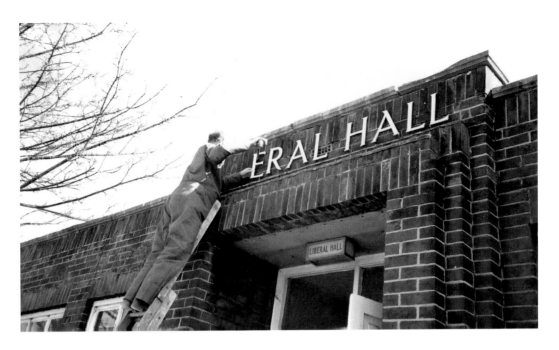

Chippenham Rotary Hall
The land on which the Rotary Hall now stands was initially open ground used as an extension to the Chippenham market. Later the Chippenham Liberals built a brick hall, which was acquired by members of the Chippenham Rotary Club and was opened for use on 24 October 1986. Before the opening, members can be seen removing the letters of the Liberal Hall, which has now been replaced by the sign of the Rotary Hall.

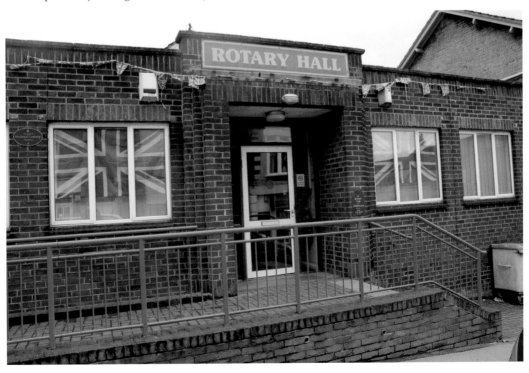

CHIPPENHAM SKATING RINK.

Roller-Skating Rink

Open ground below the sorting office was used in 1910 to construct a roller-skating rink, which proved very popular with the Chippenham community. During the First World War the rink was used as a temporary overnight billet for soldiers prior to them embarking from the nearby railway station. Soldiers billeted here in 1916 suffered a severe outbreak of measles. By the end of the First World War the popularity of roller-skating had declined and the premises changed to a garage run by W. M. Burridge, which later became Chippenham's main motorcycle dealer. After a period of remaining empty it has now been taken over by the charity Dorothy House, who have made good use of the large open space that used to be the rink.

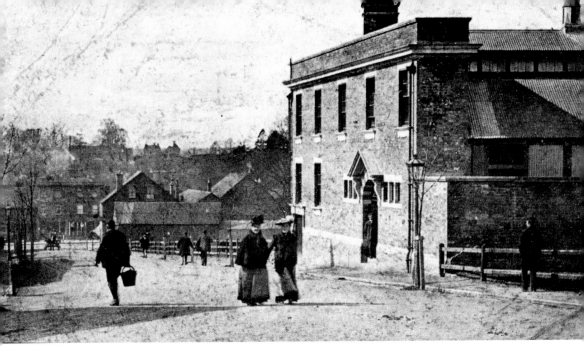

Sorting Office

Land was purchased to build the new sorting office in 1874 next to the railway; with the continued growth of Chippenham, an extension to the sorting office was added in 1964. The office closed in 2008 and has been moved to new premises on Bumpers Farm. Currently the old sorting office is awaiting redevelopment.

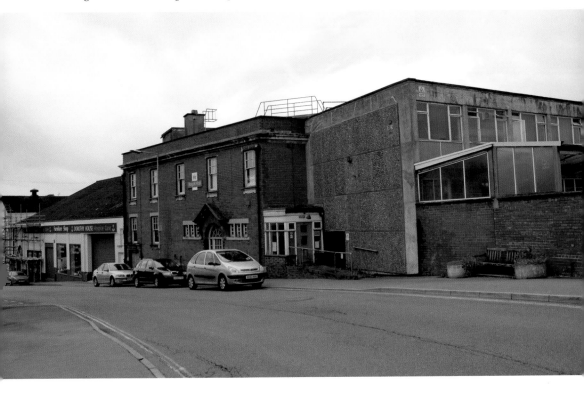

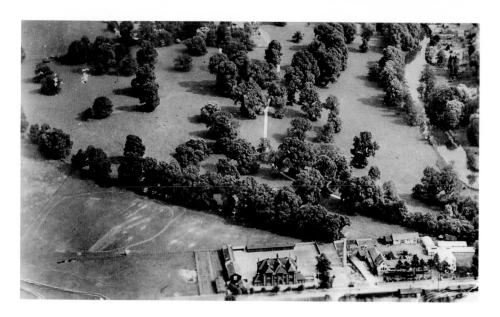

Chippenham College

Chippenham Borough Council received plans in 1898 for the building of a new Chippenham District Technical and Secondary School in Cocklebury Road near the station. The project was overseen by Alderman John Coles and the chosen design was by a well-known Bath architect's practice called Thomas Hall Silcock. The foundation stone was laid on 7 October 1899 and the building was opened in 1900 by the first chair of governors, Alderman John Coles. The siting of the school to the north of the town in green fields near the Monkton Park estate was ideal as there were areas for sport and, more importantly, there was room for further buildings to be built. By 1948 the buildings were used by the North West Wiltshire College of Further Education. Further major building work took place in 1953, 1973 and in the 1990s. Today, Chippenham Further Education College is part of Wiltshire College.

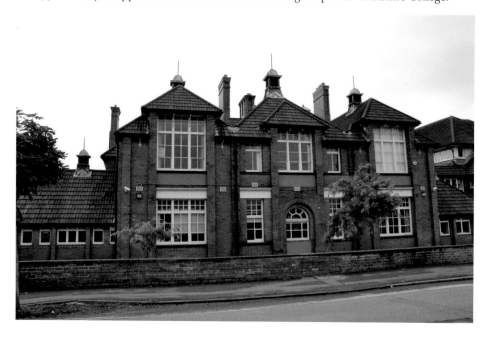

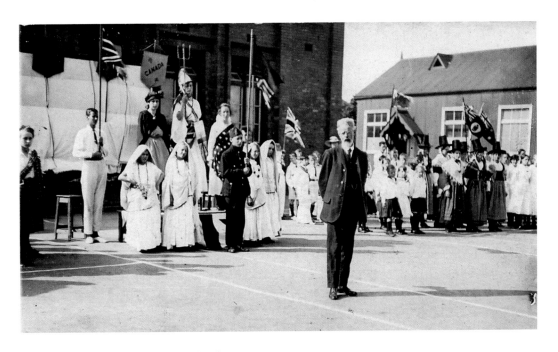

Technical and Secondary School

In 1893, Mr E. N. Tuck was appointed and successfully ran the school until 1933. He stands in the rear school area in front of pupils who are dressed in costumes from countries of the British Empire. The pupils were probably rehearsing for their entry float into the Chippenham carnival. In the background can be seen the original school building of 1900, which still remains but is now surrounded by a wide range of later additional college buildings.

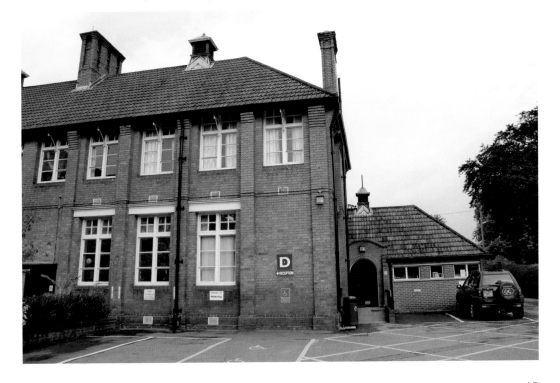

Chapter 5
Commerce and Industry

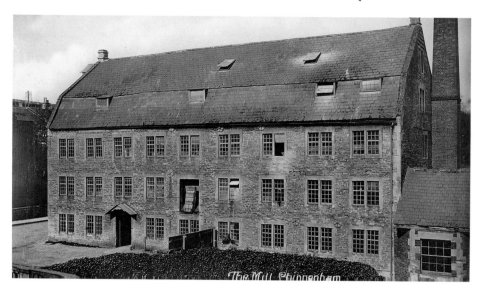

Town Mill

The Domesday Survey of Chippenham records twelve mills along the Avon; many of them were probably involved in grinding the corn on the rich cornbrash soils to the west. Later records from 1670 show that the mill was owned by the Baynton family of Spye Park near Chippenham, which they held until 1800. After the disastrous fire of 1816, the mill was rebuilt and remained standing until it was demolished in 1958. A long row of fairly plain, utilitarian shops was erected over the site of the mill facing onto New Road.

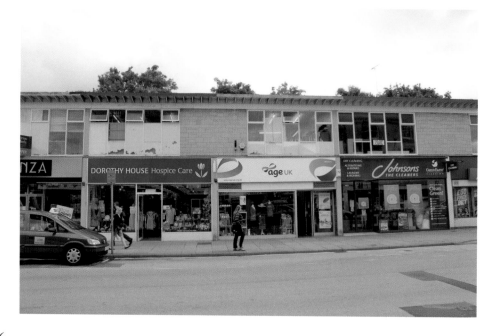

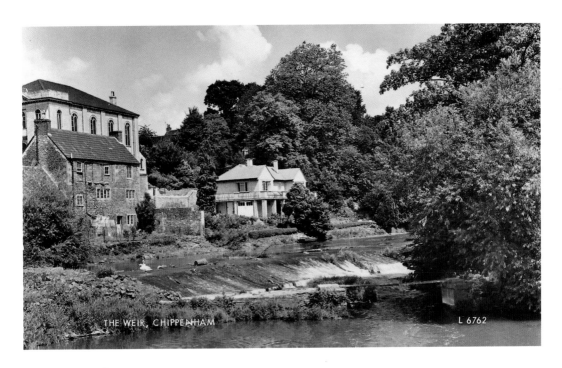

Town Weir

In order to keep a good head of water for the mill, a weir was built to the rear along with two sluice gates. Along the north bank of the river were stables and domestic dwellings. With the demolition of the mill in 1958, the whole area was redeveloped with offices. The weir was removed, along with the small islands, and the profile of the river through the town was substantially changed.

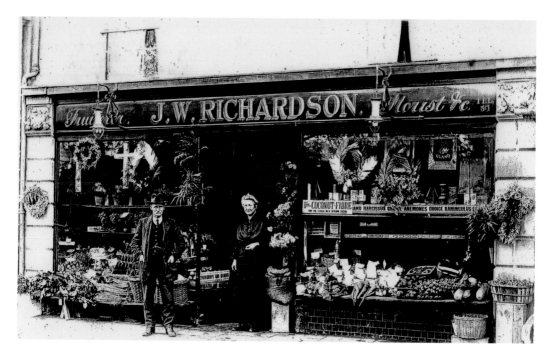

Richardson

The family business of J. W. Richardson was set up in about 1905, selling fruit and flowers. They occupied one of the new speculative buildings in a prime position, which was then called No. 3 The Bridge and is now part of New Road. The building has been substantially altered as a nightclub and bar.

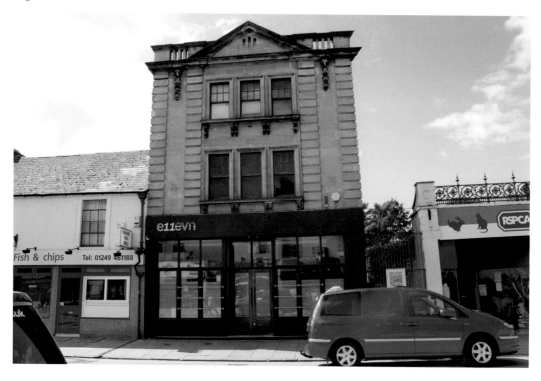

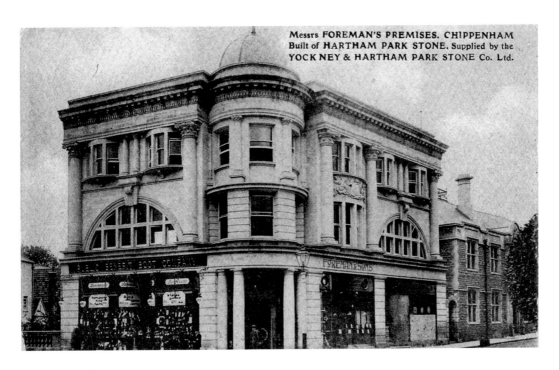

Messrs FOREMAN'S PREMISES. CHIPPENHAM
Built of HARTHAM PARK STONE. Supplied by the
YOCKNEY & HARTHAM PARK STONE Co. Ltd.

Holland's Cigarette Factory

In about 1905, a fine Edwardian Neoclassical building was erected on the corner of New Road and Foghamshire for Mr Foreman's retail business. The first and second floors of this building were taken over by Mr Holland as a cigar, cigarette and snuff factory, employing many young girls in Chippenham. With the closure of the business after the First World War, the building was used by the Prudential Insurance Company. A current scheme for this area is to make Foreman's building into a grand entrance leading into a new shopping precinct, which will be built in the existing Bath Road car park.

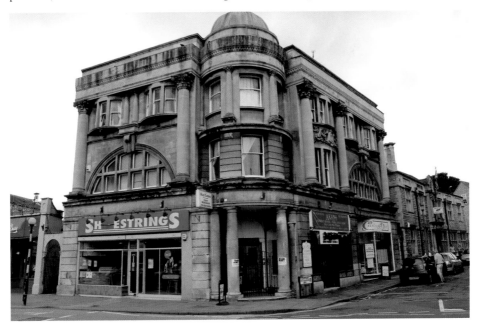

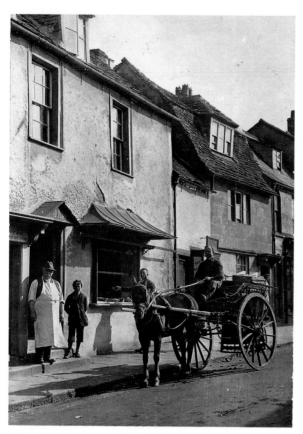

Isles & Son

In 1883, John Iles took over an existing butchery business in The Causeway and began to develop the business to compete with many other butchery shops in the town. In about 1910, John Iles stands outside his shop with William John Iles in the delivery cart. They are now one of the longest-running businesses, and the only independent butcher's shop, in the town. The business is continued by Richard Iles and his son, John Iles.

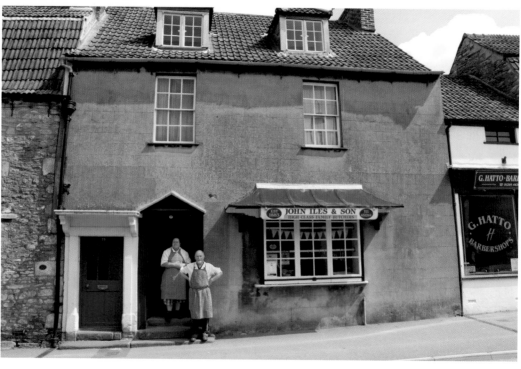

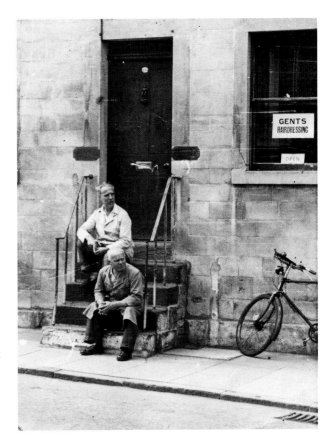

The Causeway

Many of the houses in The Causeway were once involved in the retail trade. The house opposite Iles & Son was where John Archard lived, running a hairdressing businesses. He is sat on the steps along with William Iles from across the road. Today, like many other houses in The Causeway, they have reverted to domestic dwellings.

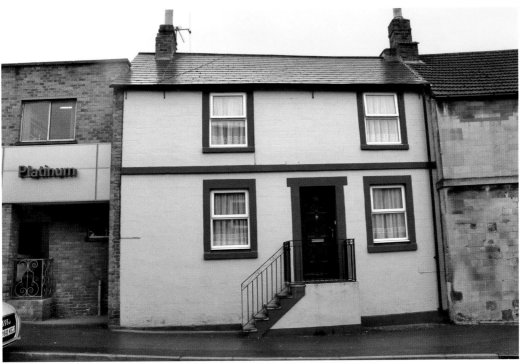

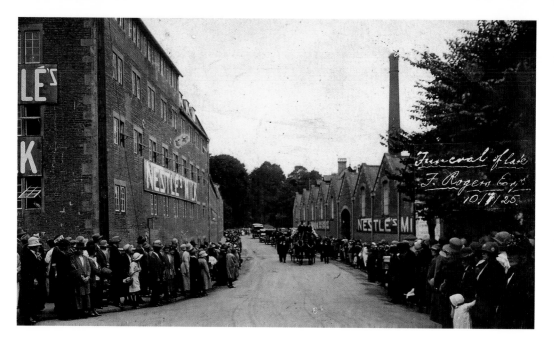

Nestlé, Bath Road

The Nestlé factory was formerly the National Anglo-Swiss Milk Company in 1873 and later became Nestlé. In 1935 some of the first modern, stainless steel plants and machinery were built into the condensed milk factory. The company pioneered the system of packing condensed milk into tin cans at Chippenham, which were also made on site. The condensery finally closed in 1962, with production being moved to a new factory in Cumberland. Some of the factory was demolished but the main building survives and has been converted into offices.

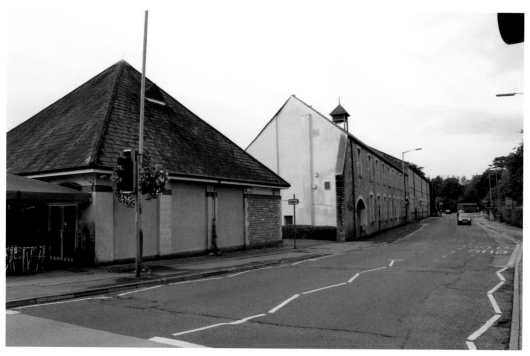

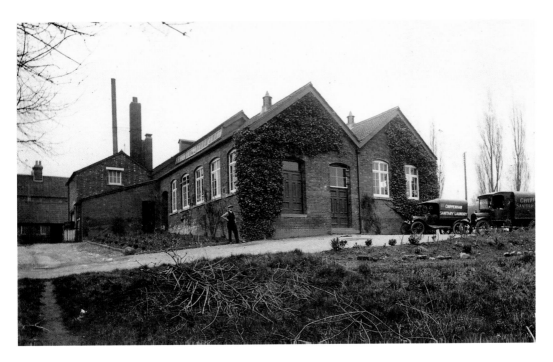

Chippenham Laundry

In the 1920s, an area to the west of Chippenham known as the Ivy Fields was acquired to build the Chippenham Sanitary Laundry. The buildings still survive and are currently used by the Chippenham Auction Rooms, Snooker Club and other businesses.

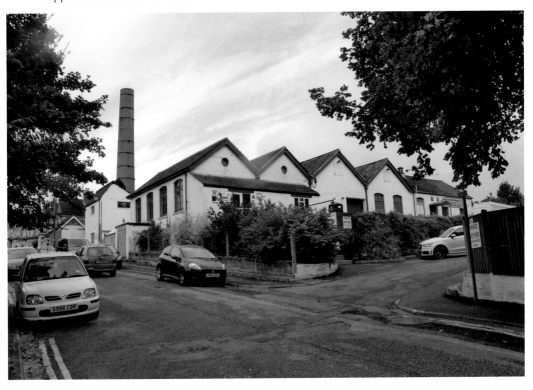

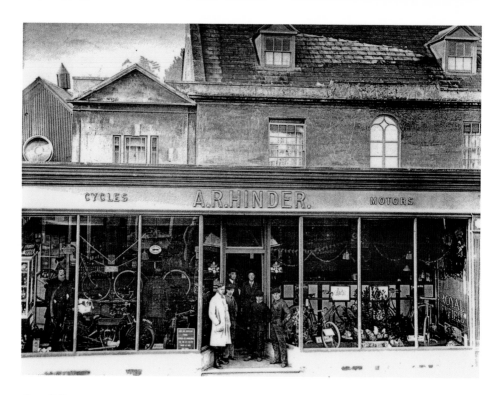

Orwell House

The house was built as a speculative development in 1812 on a greenfield site by Mr John Provis. With the arrival of the railway in 1841, Brunel's bridge and viaduct passed along the very edge of the property. The house was leased to Rowland Brotherhood and his family, who remained there until 1875, adding a rear wing. From around 1901, Mr Bardwell ran a school until 1912, when it was acquired by Mr A. R. Hinder to sell cycles and motorcycles. In April 2000 the building was both restored and changed into The Brunel, selling beverages and food.

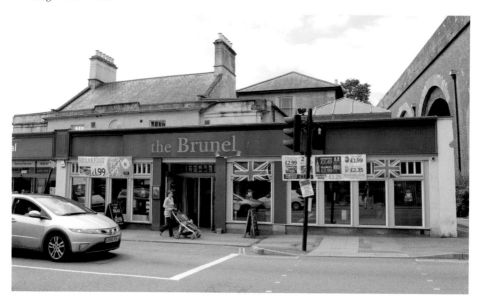

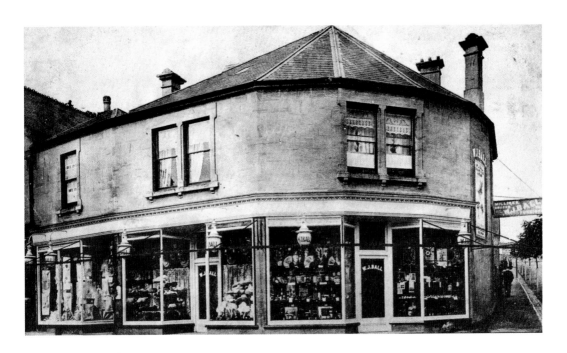

New Road Shops

The new Station Hill road was opened in 1841 and cut through Mr Provis' saw mills and wood yard. From about 1860, rows of shops began to appear from the railway viaduct to the Station Hill approach. One of the largest shops on the corner was the premises of W. J. Ball & Son who, from 1908, were drapers and house furnishers. Ball's old, large shop has now been subdivided into a cobbler's shop and fast food outlets.

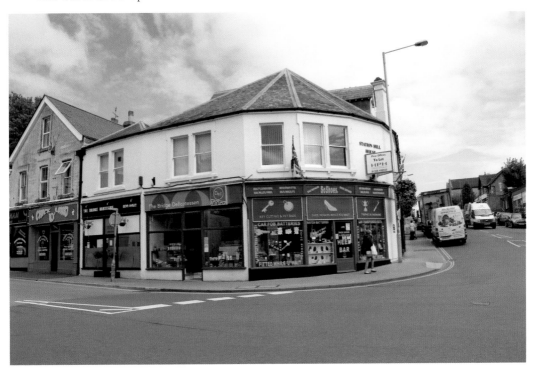

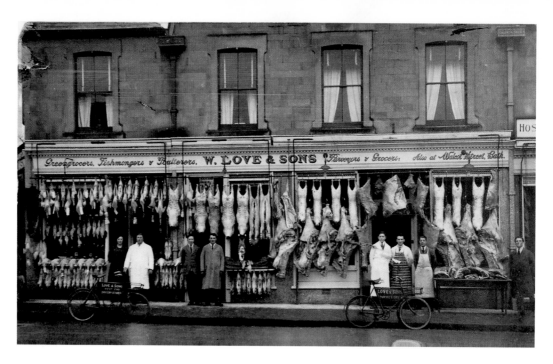

New Road Butchers

Walter Love established a fishmongers' shop in The Causeway during the 1890s and later moved to larger premises in New Road, near the railway bridge and viaduct. As his business expanded he acquired adjoining premises and ventured into both the grocery and butchery trades. The Loves had a large family, including five sons who enlisted during the First World War; all returned to Chippenham after the war.

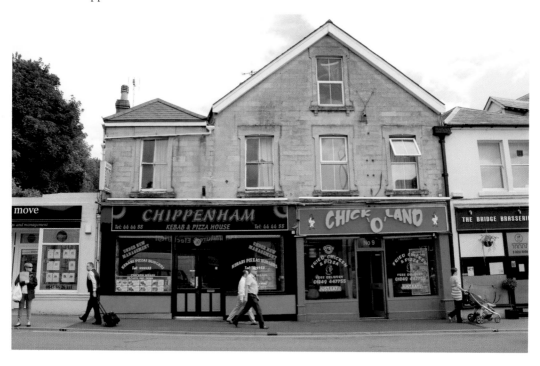

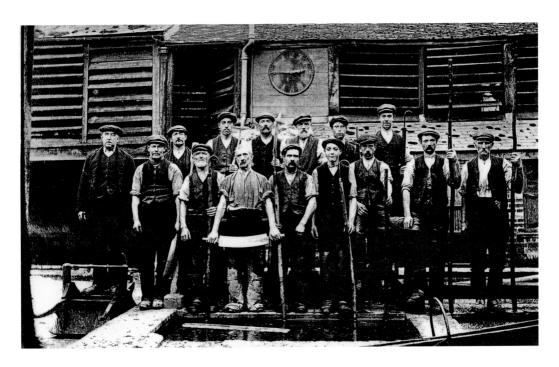

Westmead Lane Tannery

This lane was formerly known as Factory Lane and contained the gas and waterworks depots, a cloth factory and a tannery. The tannery was on the east side of Westmead Lane and was opened in 1861, run by Messrs J. and T. A. Smith until it closed in 1928. The land then became part of the George Flowers scrap business until it was sold and cleared for the erection of housing estates.

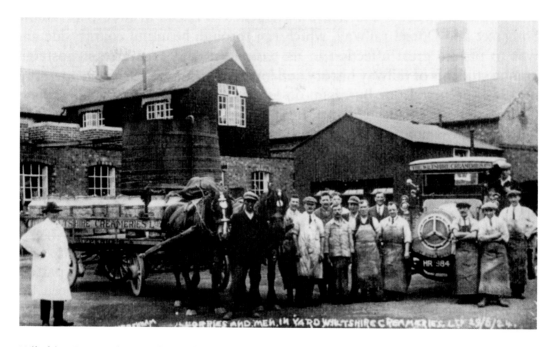

Wiltshire Creameries, Station Hill

North Wiltshire has always had an excess of milk, used to make butter and cheese or traded away from the town. The coming of the railway to Chippenham in 1841 revolutionised dairy farming in North Wiltshire, for it enabled liquid milk to be sent to London and other towns in churns. Wiltshire had a number of wholesale dairy companies for processing liquid milk, such as the Wiltshire Creameries, shown here in 1924, which was demolished after the Second World War and has been replaced by a car park.

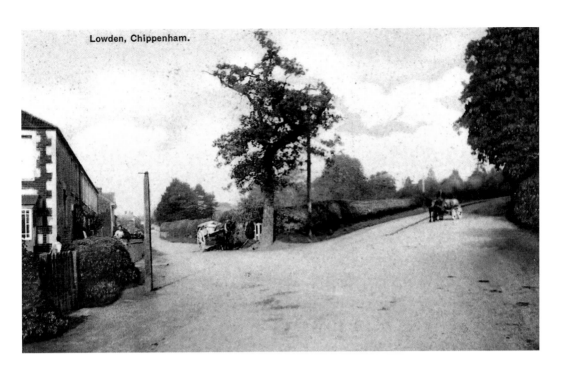

Lowden, Chippenham.

Rowden Hill

On the junction of Bath Road and Lowden, a 1786 view shows that the land behind the trees was occupied by a Georgian brickworks, supplying bricks to the expanding town of Chippenham. In Victorian times the land reverted to farmland and was later built up with housing estates in the 1980s.

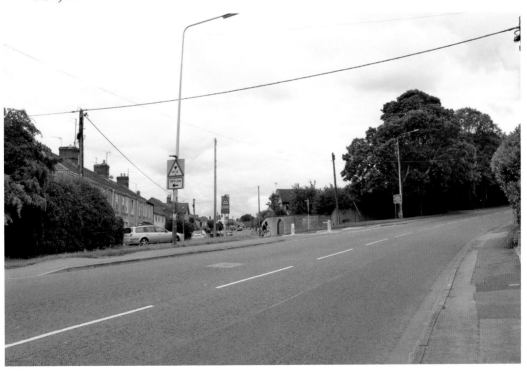

Chapter 6
Public Houses and Hotels

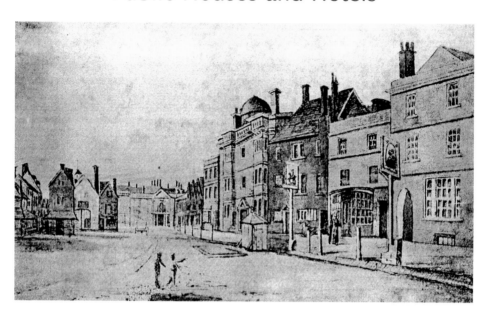

Market Place

There hasn't been a great deal of change in the front façades of the buildings fronting onto Market Place when you compare the anonymous drawing of around 1850 to the present day. Most of the fine eighteenth-century buildings were originally public houses and inns serving the town and the market users. From the right-hand side, the first building was the King's Head, next to it was the wine and spirit vaults, then the Duke of Cumberland, sometimes called The Trooper, and then further down was the imposing Bell Inn. Today this has changed to retail and commercial premises.

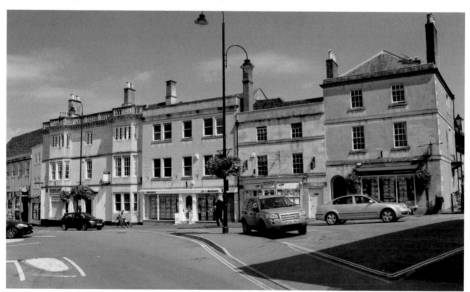

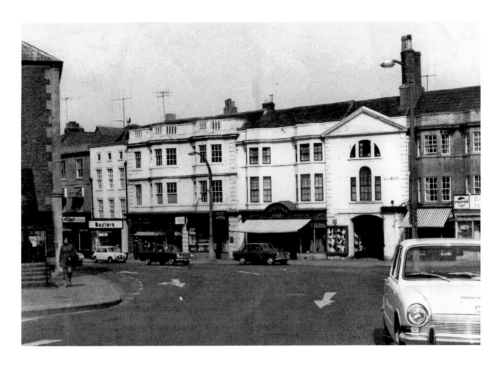

White Hart

The premier coaching inn of Chippenham from at least 1548 until 1850 was the White Hart. The building has a fine, imposing classical front with a pediment over a large door, which was originally the coaching entrance into the rear courtyard, where horses were changed and passengers alighted. This was one of the great coaching inns on the Great West Road from London to Bath and Bristol and, as such, had many historical figures staying there, ranging from Oliver Cromwell to the MP Robert Peel. The arrival of the railways killed their trade and it was sold in 1850 and divided up among different retail outlets. Most of the old White Hart today is occupied by Iceland supermarket.

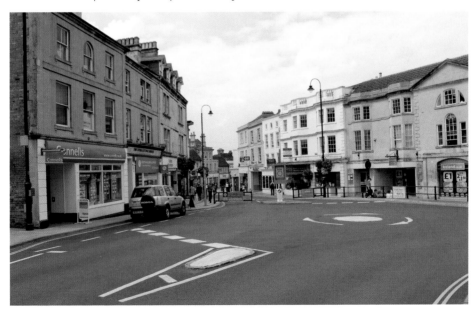

Waggon and Horses
This inn was built in about 1850 to serve customers of The Causeway, particularly those travelling to and from Chippenham's markets. The inn closed down and had several other retail uses, including the Causeway Café, before the building finally became a domestic dwelling.

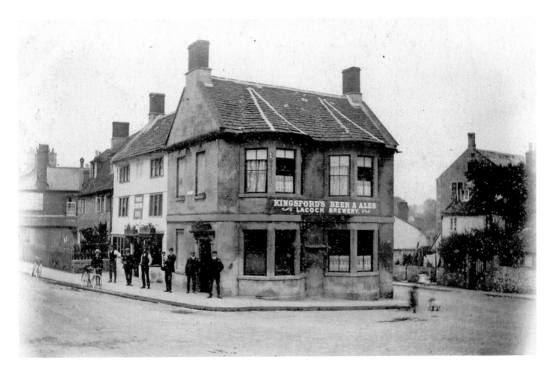

Three Crowns

The inn was sited on the junction of The Causeway and The Butts and, like other inns, made use of its location on Chippenham's market days. The first record is from 1784 and, unlike a lot of other public houses in Chippenham, it is still actively trading.

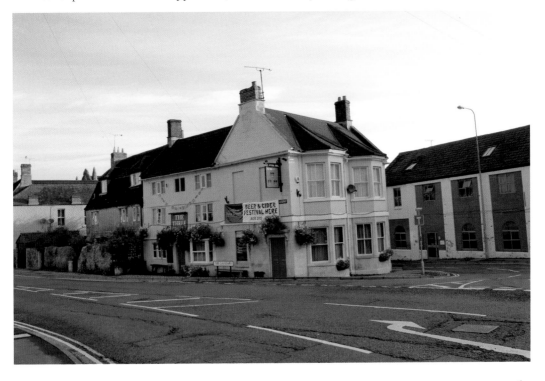

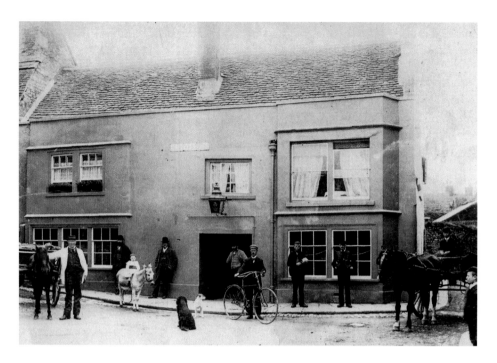

Rose & Crown

The public house in Market Place was first mentioned in a document of 1691; however, during recent renovations an inspection of the building's roofs clearly showed that it dates back probably to the fourteenth or fifteenth centuries. The building may originally have been a hall house for a rich Chippenham merchant which was later converted to a public house. As the Rose & Crown backed onto the Wilts & Berks Canal it had a name change and was called The Barge, before reverting back to its original name. The building has changed very little since the nineteenth century but it has lost its front rendering, allowing the display of its imposing brick façade.

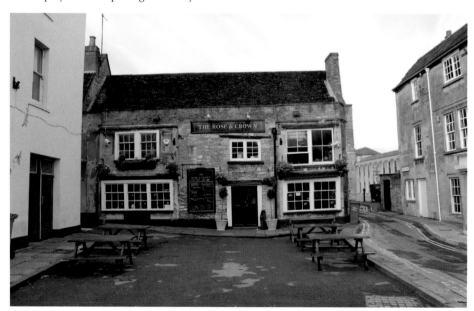

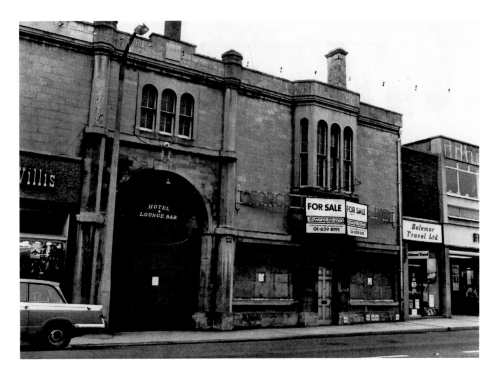

The George

The inn where W. H. Smith now stands dates back to at least 1703, and may originally have been known as The New Inn, one of Chippenham's three coaching inns. In 1784, it was renamed The George Inn after King George III. The building became empty in 1975 and was acquired by W. H. Smith & Son. Prior to the store's opening, limited archaeological excavations were carried out which detected an earlier building, dating back to the medieval period.

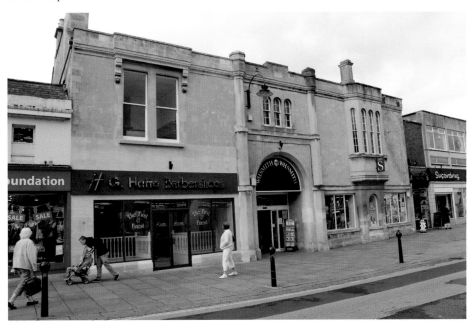

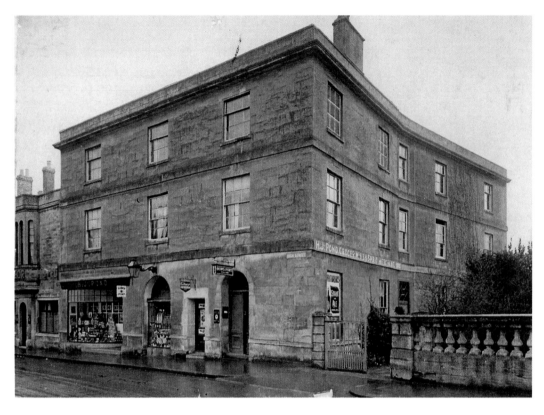

The Bridge Inn

The site of this store was originally an attractive Georgian inn which, due to its location, was called The Bridge. The building also served as a hotel, off-licence and grocery store run by Mr H. J. Pond. In the 1960s, the building was demolished and rebuilt and opened as Burtons supermarket, which in turn became Fine Fare and is presently Superdrug, with a hairdressing salon above.

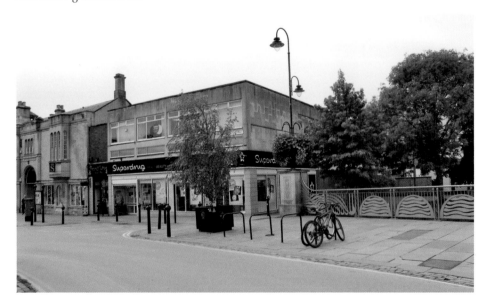

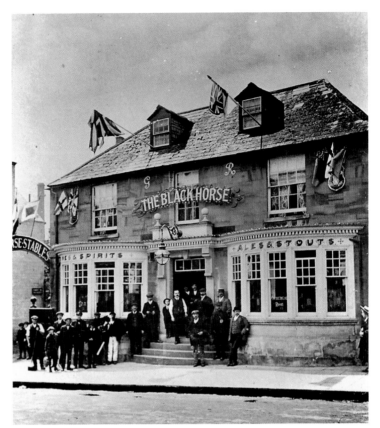

Black Horse

The inn was originally built on Monkton Hill to take account of passing traffic coming along the old road into Chippenham. With the arrival of the railway in 1841, the route was closed and the site was sold to the Wesleyan chapel. A new Black Horse was built in 1842 in New Road and is still trading.

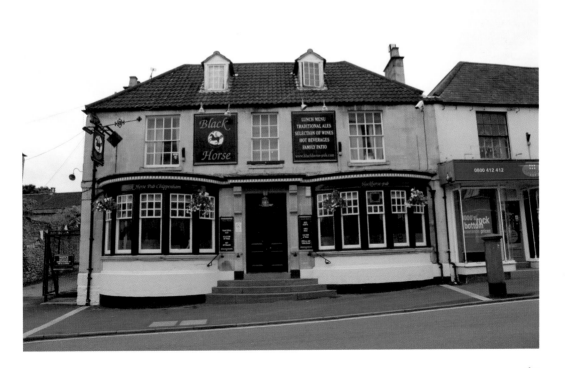

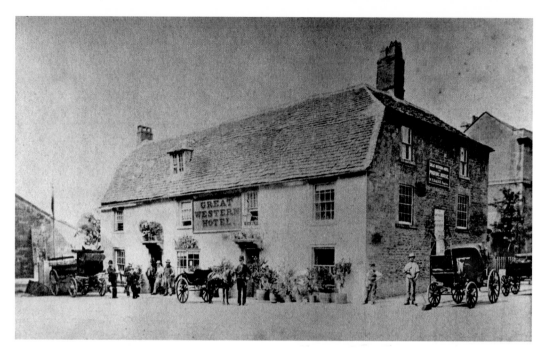

Great Western Hotel

With the arrival of the railway in Chippenham in 1841, the railway directors instigated the construction of a new company hotel, built on the side of the railway viaduct at the bottom of Station Hill. The hotel was also a commercial inn and posting house, allowing railway travellers to alight at Chippenham and leave the hotel on pony carriages, post-horses, fly carriages and phaetons. The hotel was demolished in 1967 when the road system in this area was changed, adding an underpass, which in turn has also been removed. Part of the site of the hotel is now under the multi-storey office block which was built in 1976 and was called Bewley House and originally housed offices of the North Wiltshire District Council.

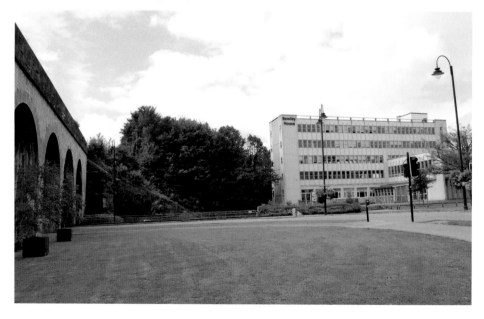

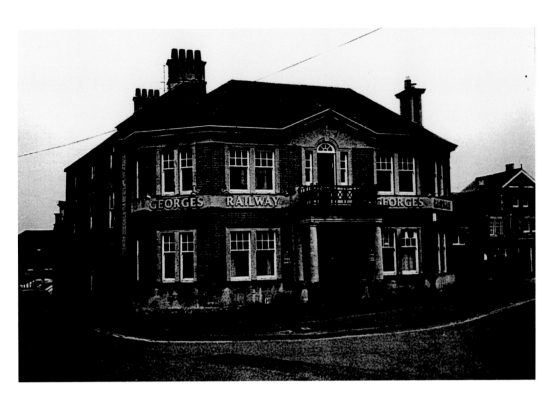

The Railway Inn

The inn was opened shortly after the arrival of the railway in 1841 and was built on the corner of Union Road and the old road backing onto Slades Brewery. The building has been architecturally altered and, with its closure, was acquired for conversion to flats. The architects have very skilfully cleaned and preserved the structure in its Queen Anne Revival style.

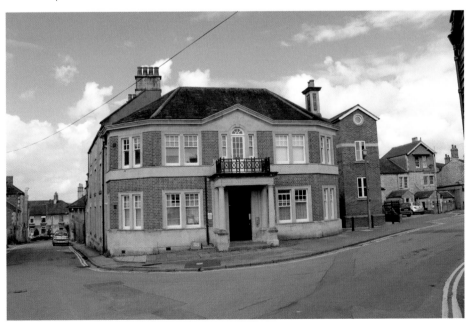

Chapter 7
Houses and Streets

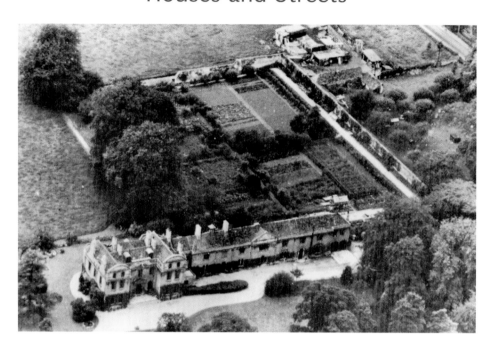

The Ivy

The Ivy still stands in the centre of its own grounds, right in the centre of Chippenham. Parts of the house probably date to the seventeenth century, to which was added a large, new main block sometime between 1725 and 1730 for John Norris, a rich Bath lawyer, who formerly lived at the nearby Sheldon Manor. In 1801 the house and estate was owned by Mr Humphreys and later it was acquired by the Rooke family, who lived there from 1870 to 1974. In 1975 the premises and parkland were sold, the developer building housing estates on part of the land to the south. The main building was then converted into four very large and comfortable apartments, many of which contain period features from the eighteenth century.

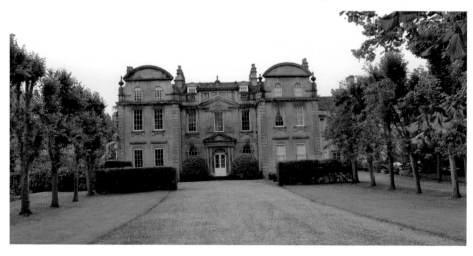

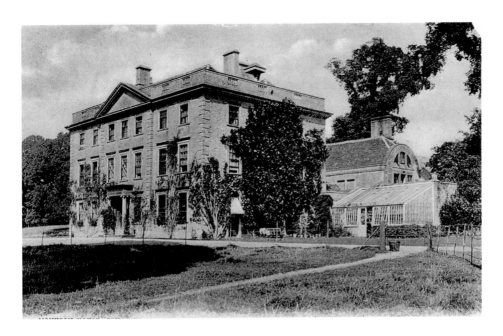

Monkton House

In 1150, the Crown of England gave land at Cocklebury in Chippenham parish to the Cluniac monks of Monkton Farleigh to build a monastic grange. At the Dissolution of the Monasteries under King Henry VIII, Monkton Manor came into the hands of the Seymour family. Later owners converted the old manor house into a Jacobean house and then later, in 1757, Esmead Edridge converted the house into the latest fashionable Georgian style. In 1957 the Monkton and Cocklebury estates of 120 acres were sold for building land. The Grade II listed Monkton House was converted into well-appointed flats, with a pitch-and-putt course to the west side, all within what remains of the Monkton Park estate.

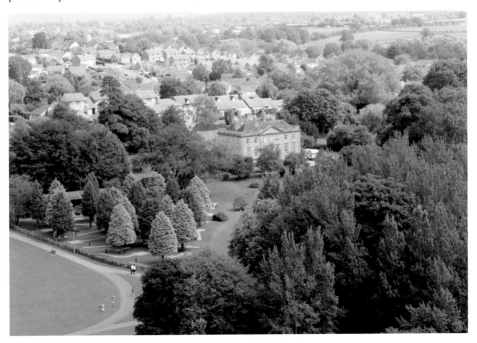

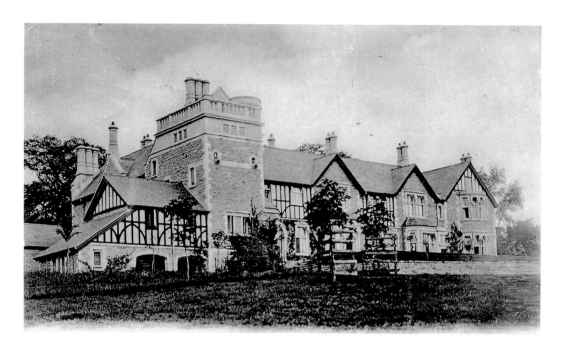

Greenways House

The house was built for Captain Allfrey in about 1900. The style contained elements of timber framing and high-pitch roofs. The house was an eclectic mix of the Tudor style and Edwardian, with a hint of the Arts & Crafts Vernacular style, set within an area of land which overlooked Birds Marsh Wood to the east and Chippenham to the south. In 1950, the house was fitted out as Greenways Maternity Hospital. Later the house was totally demolished and the area was changed into an out-of-town retail and office park.

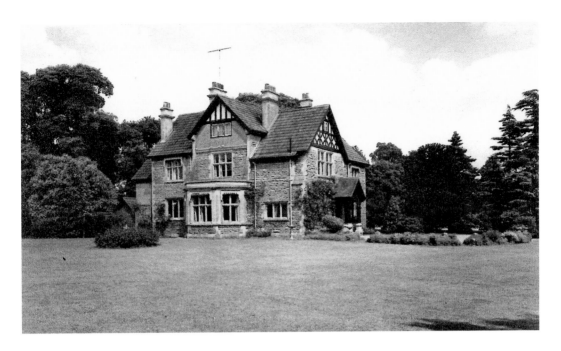

Ferfoot Care Home

The Hathaway family set up a butter churn manufacturing company in Chippenham in 1869 in London Road. Later, as the company expanded, they moved into the old Brotherhood railway factory and manufactured products of quality, enabling them to build a brand-new house from scratch at Ferfoot around 1890 on the edge of the Hardenhuish estate. The house remains today but has been substantially added to and is now one of the main care homes in Chippenham.

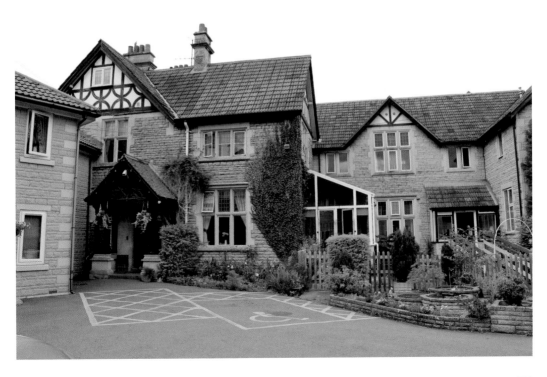

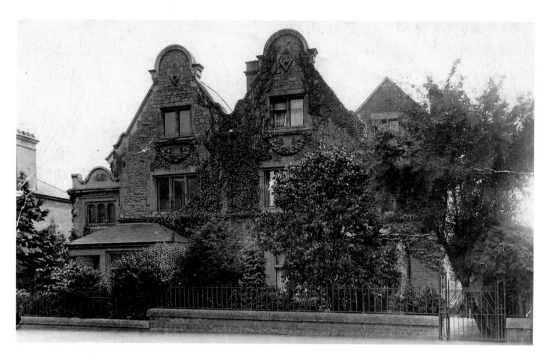

Marshfield Road

The town of Chippenham expanded from the 1850s with the arrival of railway engineering companies. There was a great need for houses for all classes of workers. Along Malmesbury Road some fine Victorian buildings were erected; on the south side, before the turning to Gastons Lane, a Dutch-type gable pair of houses was constructed. Apart from the removal of ivy and trees, the houses remain little changed.

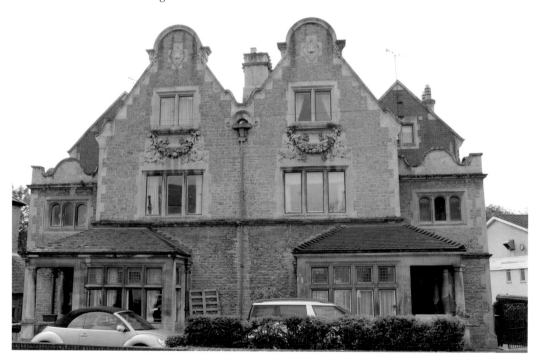

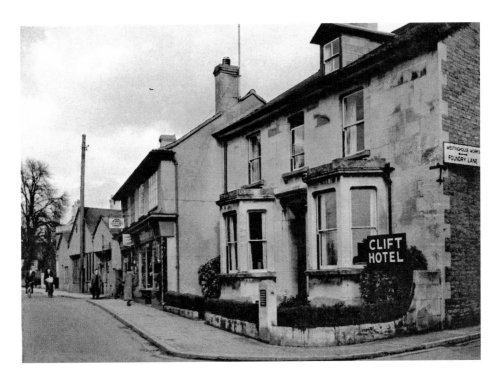

Clift House

The house was originally built as a hotel run by Mr W. H. J. Cockram; next door he also had a flourishing greengrocer and florist. The house is currently used as offices. On the front wall is a plaque which attests to the end of Maud Heath's causeway. Maud Heath was a widow living at Tytherton Kellaways and on 12 June 1474 made a Deed of Gift in which land and property in Chippenham was vested in a group of trustees. The income from the bequest was to repair houses and the balance used to make and maintain a causeway from Wick Hill to Chippenham, ending at Clift House.

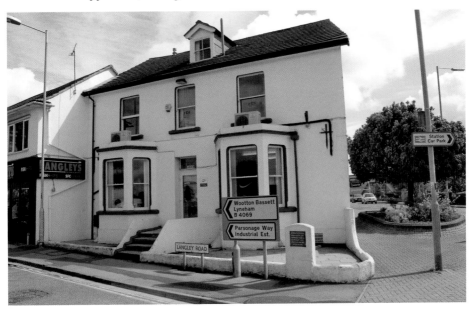

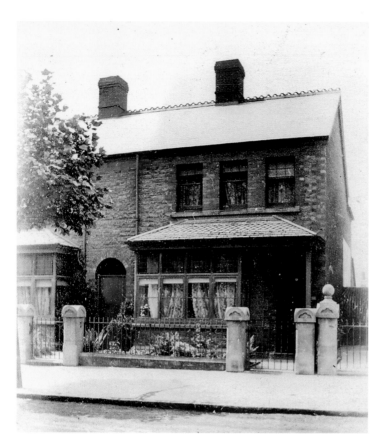

York Villas

The Malmesbury Road, stretching away from St Paul's church, was built up with a variety of styles of houses for people who mainly worked at the railway engineering works. York Villas has altered little over the period, apart from some damage to the front walls and the removal of the railings for the war effort.

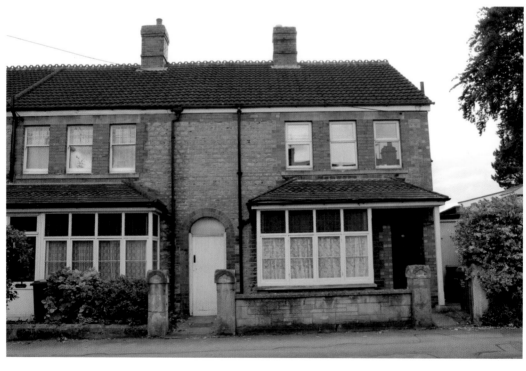

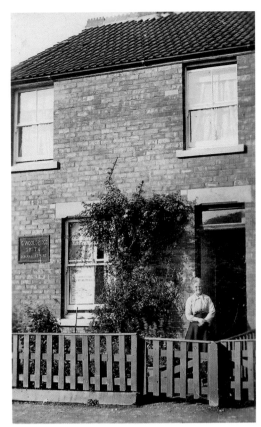

Ladyfield Road

The Ladyfield Road estate was erected in part before the First World War and was continued after 1919. At No. 16, Mr G. Wooldridge, a smith, carried out his general repair business; his wife poses at the front door. The red bricks have now been rendered and the windows replaced with uPVC double glazing.

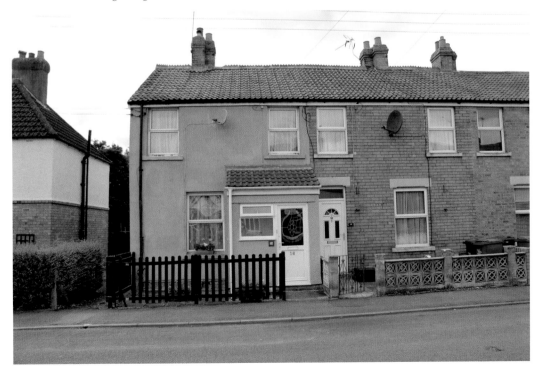

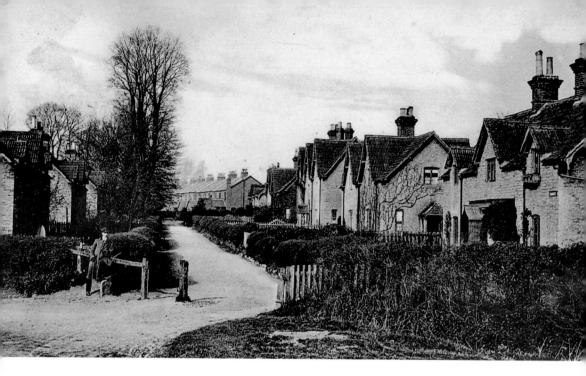

The Hamlet

This row of cottages and small houses was once the property of the Ash family of nearby Langley Burrell Manor and was known as Ash's Cottages. The name was later changed to The Hamlet around 1900, as the row of buildings was very isolated. Today, there are housing estates all around the area of The Hamlet.

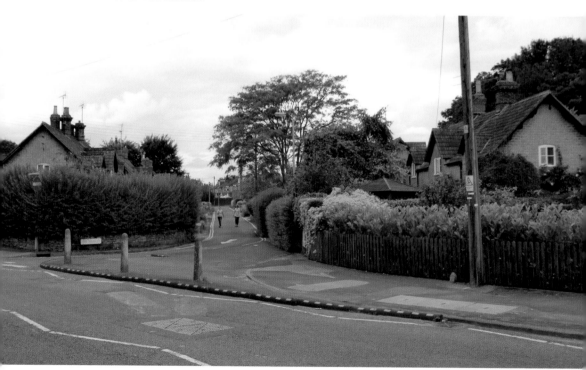

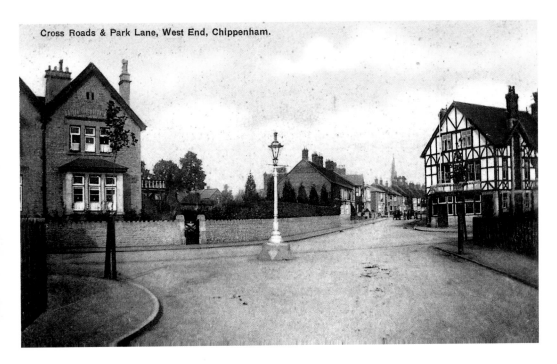

Cross Roads & Park Lane, West End, Chippenham.

Old West End Club

The area at the end of Park Lane originally joined Landsend, which was the edge of Chippenham. The town continued to expand and in 1906 Landsend was renamed Marshfield Road. On the corner of Marshfield Road and Park Lane, a new West End Workmen's Club was constructed sometime around 1905. The Workmen's Club moved across the road and the buildings were converted to flats. The building on the opposite corner was formerly a town house, which later became Chippenham's police station, and then beginning its association with the Wiltshire Probation Service.

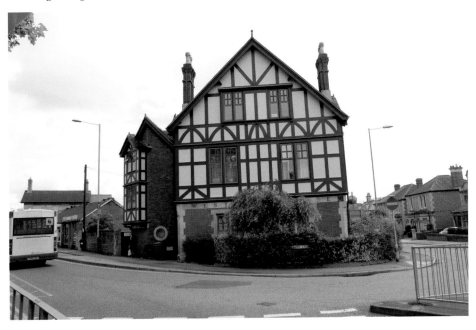

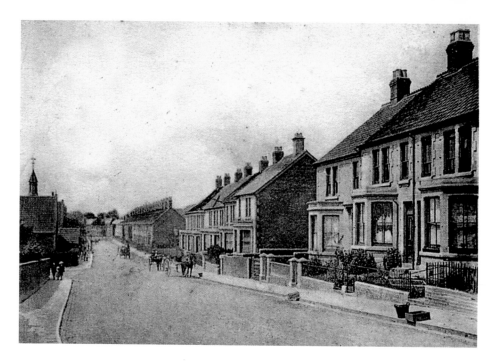

Park Lane

Looking west along Park Lane in 1893, the rows of new domestic dwellings can be clearly seen. The lane was originally called Little George Lane and led out to the open countryside. In 1957, the Reverend Robert Ashe gave land for the building of St Paul's National School, which opened in 1857 and cost £1,900. In the 1970s the old school buildings were demolished and replaced with houses and flats but retained the old schoolmaster's house.

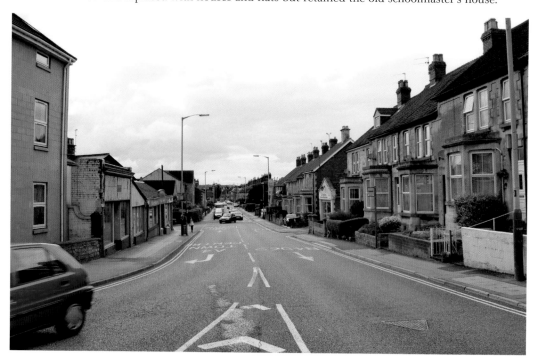

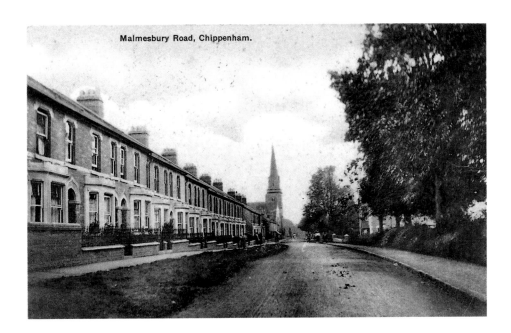

Malmesbury Road, Chippenham.

Malmesbury Road

Looking east down Malmesbury Road towards St Paul's church, the late Victorian terraces can be clearly seen. The green fields opposite were to be used in 1923 to build John Coles Park. In his will of 1916, Alderman John Coles left £4,000 to be devoted to the cultural and educational advancement of the people of Chippenham. The legacy was invested and, with other loans, was used to purchase 15 acres of land to build John Coles Park, which was opened to the public on 23 May 1923.

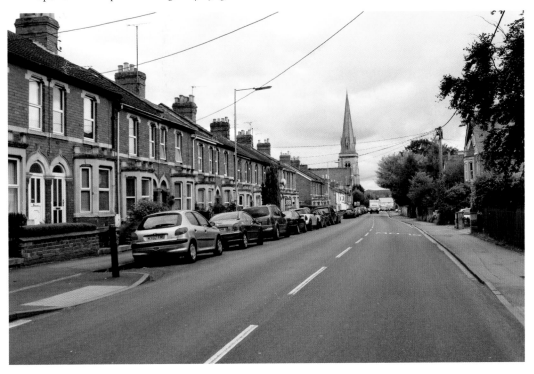

Chapter 8
Religious Buildings

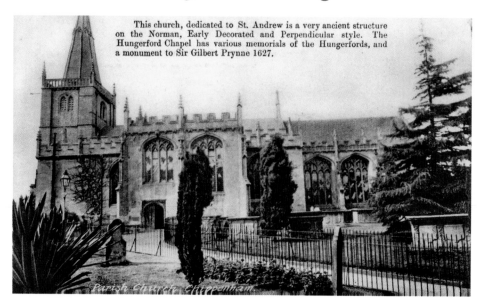

This church, dedicated to St. Andrew is a very ancient structure on the Norman, Early Decorated and Perpendicular style. The Hungerford Chapel has various memorials of the Hungerfords, and a monument to Sir Gilbert Prynne 1627.

St Andrew's Church

The church, within its graveyard, lies at the heart of the Saxon and medieval town of Chippenham. The earliest reference to a church or chapel is in 853 and by 1120 a new building in the Norman or Romanesque style was commenced. In the fourteenth century, profits from the wool trade were used to enlarge the church. Due to the growing population, in 1878 a major enlargement and restoration took place.

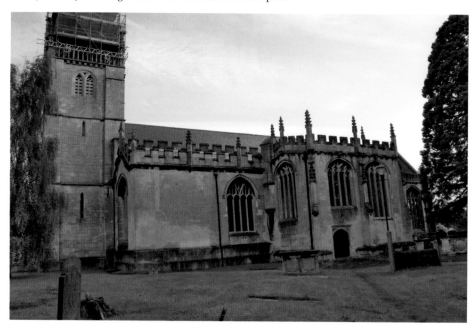

St Andrew's Church Spire

The spire of the church was built in 1633 and has been repaired on many occasions. In 1904 the spire was repaired, with men showing little regard for modern health and safety. Further work was carried out in 1949, when builders had to rebuild the top 20 feet of the spire. In 2012, further work is currently underway but differs from previous work by having a very substantial and safe form of access for the stonemasons to carry out their work.

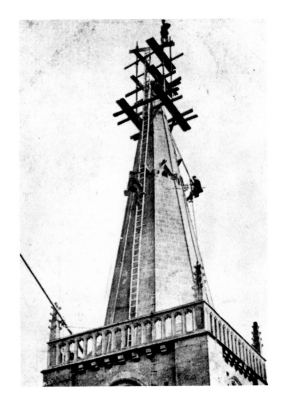

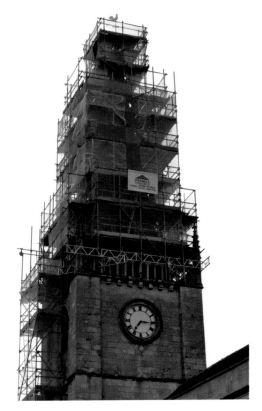

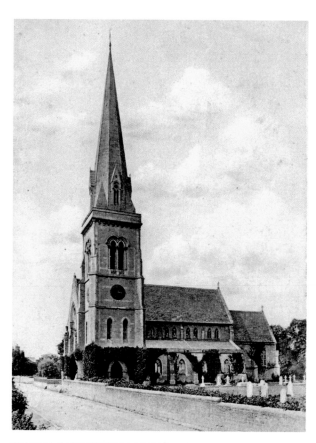

St Paul's Church

With the growing population of Chippenham, the church authorities decided to build a new church on the north side, which was commenced in 1853. It was designed by the nationally famous architect Sir George Gilbert Scott. The church still dominates the area and can be seen from many miles away.

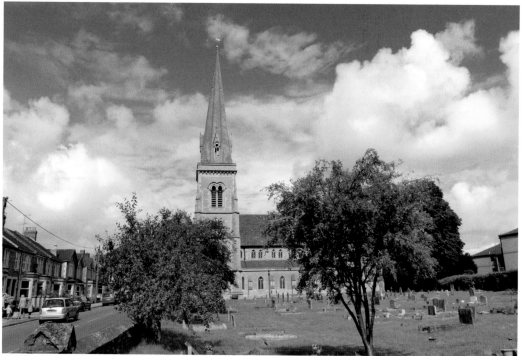

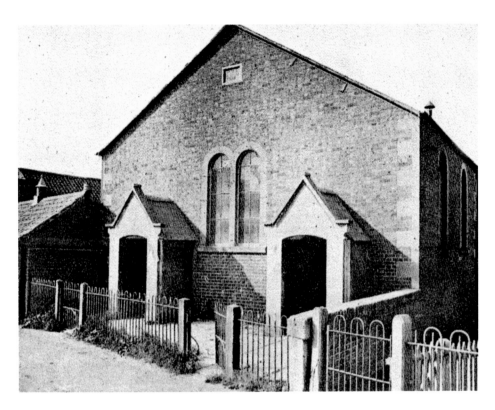

Lowden Methodist Church

In 1855, due to the growing population of the suburb of Lowden, the Methodists decided to build a new Primitive church. The church became redundant and by the removal of the two front porches it was changed into a garage owned by Chequers. Further use has been made by a sign company, but the building is now empty and awaiting new ownership.

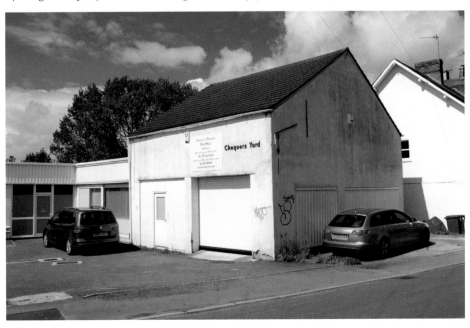

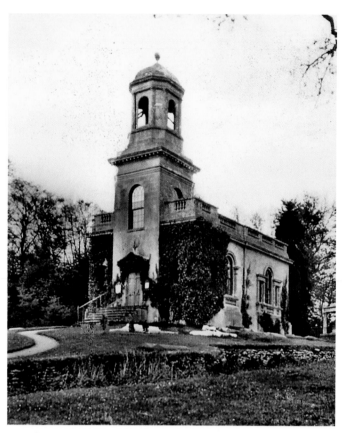

St Nicholas, Hardenhuish

The owner of the estate at Hardenhuish, Mr Joseph Colborne, decided to build a new house for himself and a new church, as the existing ones were both considered old-fashioned. The old church and manor house were demolished and by 1779 the new church of St Nicholas stood proudly on the summit of the hill at Hardenhuish. The church was designed by the famous Bath architect John Wood and is built of fine ashlar masonry, with the large Venetian windows in vogue at the time. To the rear of the church is an interesting monument to David Ricardo, an important economist who died in 1823; his most famous work was *Principles of Political Economy and Taxation*.

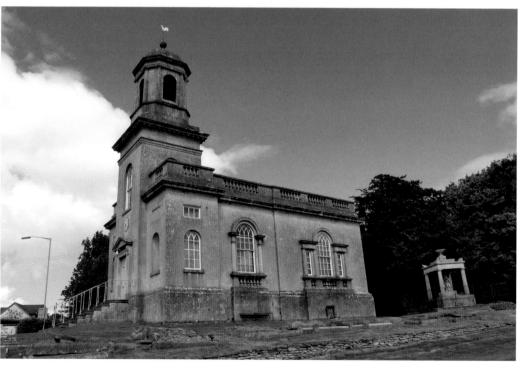

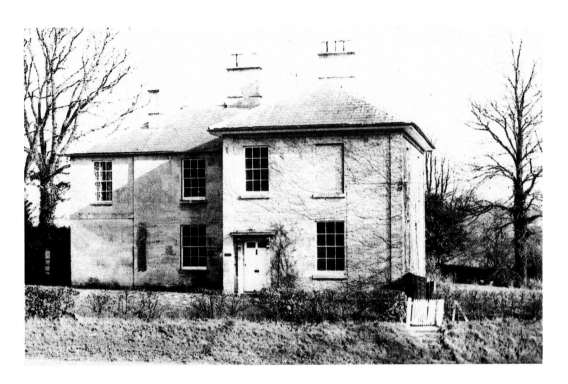

Hardenhuish Vicarage

The vicarage was built at the same time as St Nicholas church opposite, with commanding views over the surrounding countryside. Here, on 3 December 1840, Robert Francis Kilvert was born to Robert Kilvert, rector of Langley Burrell, and Thermuthis Kilvert. Robert Francis Kilvert, after graduating from Oxford, entered the Church of England and worked primarily in the Welsh marches. From 1863 to 1864 he was curate to his father at Langley Burrell. The reverend Francis Kilvert is best known as the author of diaries describing rural life, which contain many references to the land and people in and around Chippenham.

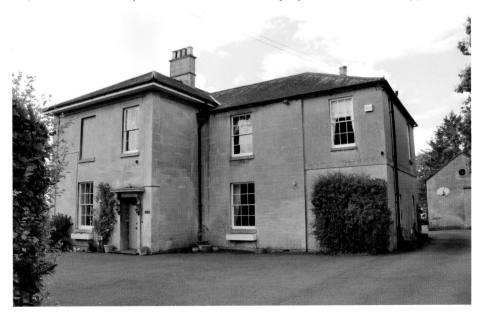

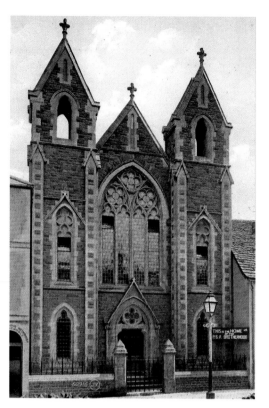

Causeway Methodist Church

The Methodist church was opened in 1896 on the centenary year of Primitive Methodism in Chippenham. Prior to the building of the new church the Methodists met in the old Quakers' schoolroom, which they bought in 1834. In 1911, delegates of the Pleasant Sunday Afternoon Brotherhood and similar societies met for interdenominational services every week in the church. After the church became redundant it was privately purchased and has been turned into the Cause Music and Arts Centre. The owners aim to support music, art and community services and at the same time sustain and conserve the historic church buildings for the enjoyment of the local community.

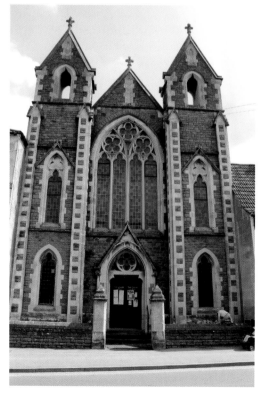

Chapter 9
Railways and Engineering

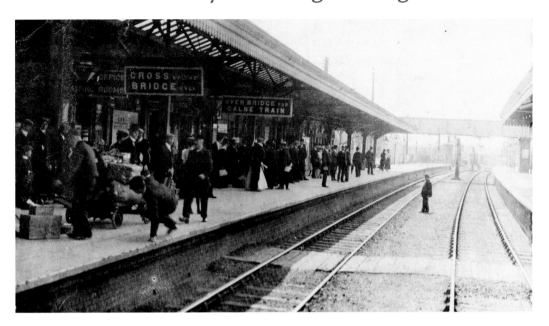

Chippenham Station

The station at Chippenham was opened for public use on 31 May 1841, even though it was incomplete. Following the completion of the Wilts, Somerset and Weymouth Railway in 1857, Chippenham was provided with an enlarged station with engine and goods sheds. At an unknown date a large, spanned roof was erected over the platforms and was later removed.

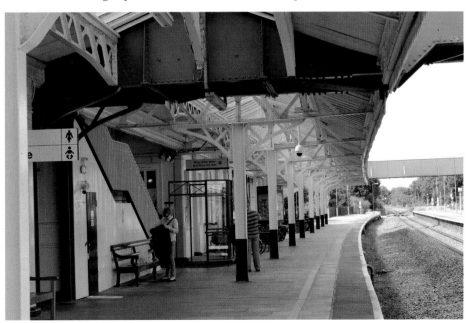

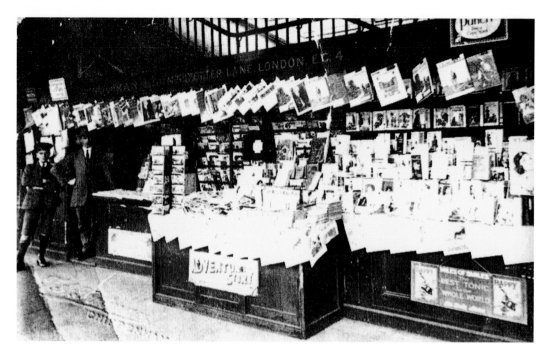

Chippenham Station

Wyman's of London opened a whole series of newspaper stalls along the Great Western Railway line; this very open stall was near the entrance to the platform from the ticket office. Today, there is nothing left of this very public display of newspapers and periodicals.

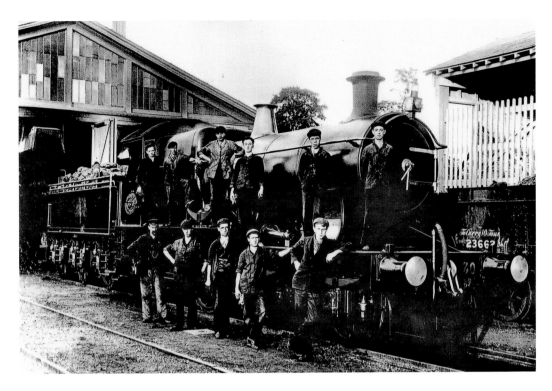

Chippenham Engine Shed

A new Chippenham engine shed was opened in 1858 and it may have replaced or incorporated part of an earlier broad gauge, timbered depot on the same site. The railway workers have posed for a picture after cleaning up the locomotive prior to use. In March 1964, the shed was closed and many of the surrounding railway sidings and buildings were demolished and have now been covered by a railway car park.

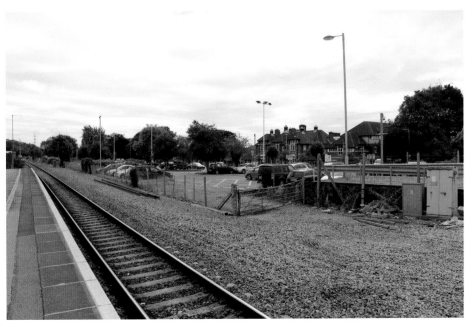

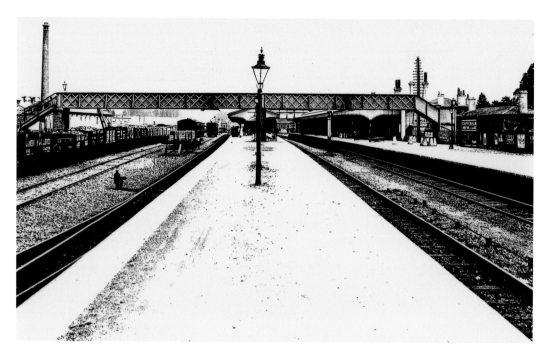

Chippenham Station Footbridge
At the beginning of the twentieth century a new iron footbridge was built across the line, allowing the public to cross from the old road into the station complex. After much repair the bridge is still in constant use and plans have been approved to install lifts from the bridge to the platforms.

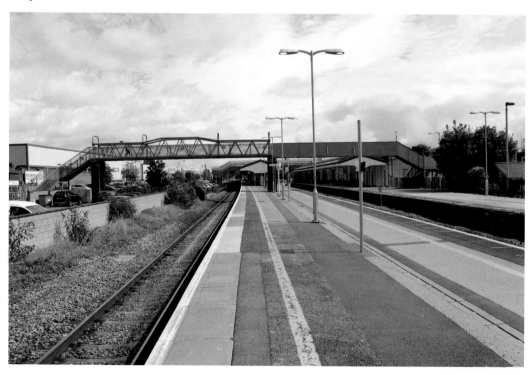

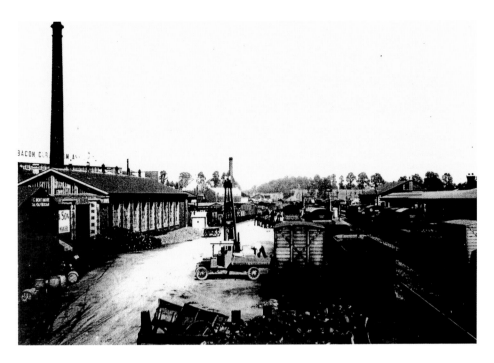

Mortimore's Coal Yard

During the early days of the construction of the railway line to Chippenham, Harding & Son opened a depot for coal, coke, salt and hay in 1840. In 1889, Frederick Mortimore became a partner with Hugh Harding. In 1890, with Harding's death, the Mortimore family took over the business until 1980, when it was taken over by Bristol-based Silvey Group. Not long after, the site was acquired for an additional northern railway car park. Only the timber building and weighbridge from the coal yard survive today.

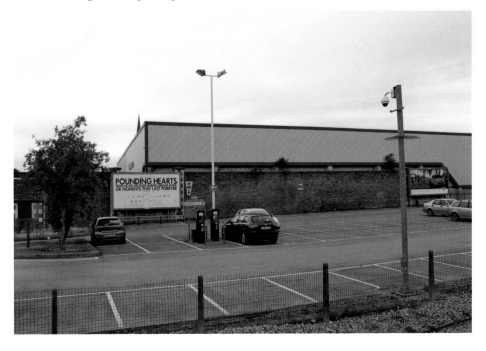

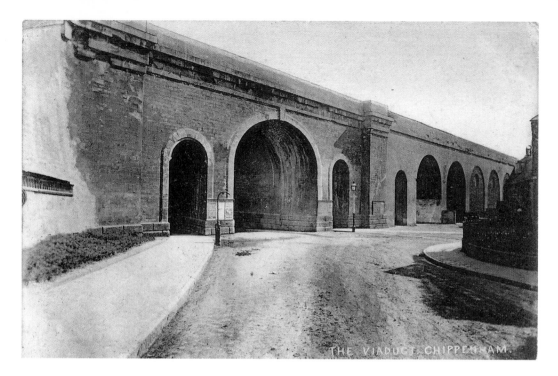

Chippenham Railway Bridge

The Great Western Railway engineer I. K. Brunel designed an imposing Doric-style bridge to cross New Road. The bridge was originally constructed of Bath stone, and in 1857 an additional 10 feet was added on the north side. Over the passage of time the south side has had its Bath stone replaced with engineer bricks. The main arch, of 26-foot span, acts as an impressive classical arch, welcoming people from new Chippenham on the north into old Chippenham on the south side. The clearance of buildings on the north side allows the public to view Brunel's exemplary structure.

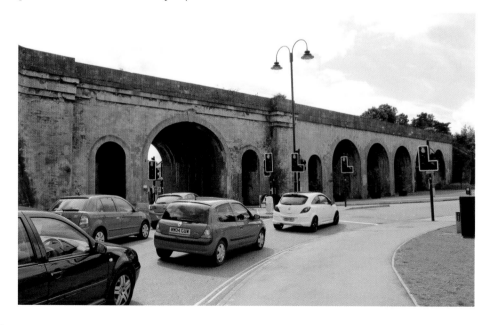

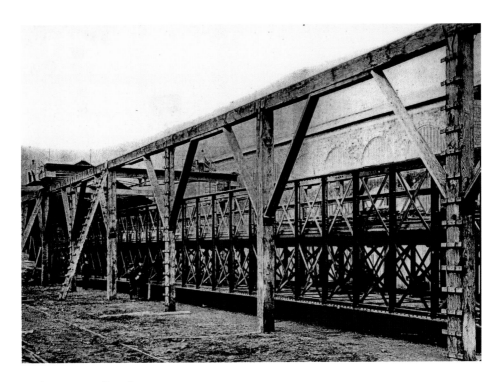

Hathaway Retail Park

In 1842, the engineer Rowland Brotherhood set up his railway business on land north of the railway station. Soon after 1842 he began to build a new railway engineering works, manufacturing railway wagons, switches, crossings and signals for the Great Western Railway. This early photograph, dated to about 1850, shows some of the outbuildings attached to the main brick-built factory. The works were eventually acquired by Westinghouse Brake and Signal Company, who utilised some of the buildings before the land was sold off for redevelopment. The site has now been cleared and a small row of retail businesses has been erected, taking its name from Hathaway's, who used to make butter churns on the site.

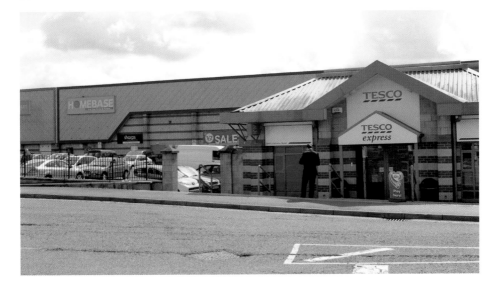

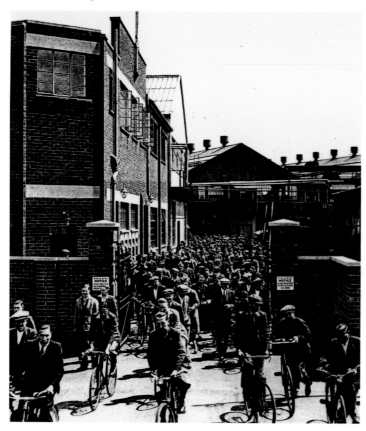

Westinghouse Brake and Signal Company

In 1920, Westinghouse Brake Company Limited combined with Saxby & Farmer Limited. Their title was the Consolidated Signal Company Limited and McKenzie, Holland and Westinghouse Power Signal Company Limited. In 1935 the company was renamed Westinghouse Brake and Signal Company Limited and became the major employer in the Chippenham area. The exit down Foundry Lane was the main way that the workers left to return home; this was all cleared away as the company sold off land for the building of Hathaway Retail Park.